Redesigning Identity

GRAPHIC DESIGN STRATEGIES FOR SUCCESS

ROCKPORT

Redesigning Identity

GRAPHIC DESIGN STRATEGIES FOR SUCCESS

Catharine Fishel

GLOUCESTER MASSACHUSETTS

ROCKPORT PUBLISHERS

First published in the United States of America by:
Rockport Publishers, Inc.
33 Commercial Street
Gloucester, Massachusetts 01930-5089
Telephone: (978) 282-9590
Facsimile: (978) 283-2742

ISBN 1-56496-624-0

10 9 8 7 6 5 4 3 2 1

Designer: Tom Hawley

Printed in China

Copy on page 12 from *Brand Strategy* newsletter,
Centaur Publishing, 49250 Poland Street, London W1V 4AX.

For Alex, Andrew, and Sam,
three best friends and brothers.
Thank you for your creativity
and humor, and for letting
Mom hog the computers when
she is on deadline.

Contents

INTRODUCTION

THE BEAUTY OF AN IDENTITY REDESIGN project is that the client comes to the designer with a brand new vision. The client has made a decision to discard or reshape an old identity that probably was very safe and familiar. But over time, the client develops a better idea of its strengths and weaknesses as well as exactly where the business ought to go.

So the client puts him- or herself completely into the hands of a designer. In the case of a brand new identity—a daunting enough project—the designer must create enough of a presence that the client can survive and prosper. But for an identity redesign, the task is even more challenging. In addition to the usual considerations of the market and aesthetics, client and designer must consider emotional issues. Does the old identity have equity that must be preserved? Will the client's employees and customers become wary or turn defensive when presented with something new? How much risk is the client willing to accept? A poorly judged response to any of these questions could cause the client's business to suffer or even fail.

There are as many reasons to redesign an identity as there are businesses in the world. Even so, these reasons can be organized into general categories, as are the chapters of this book.

- Repositioning: An identity in need of repositioning usually does not represent a company that is struggling. Instead, the business is looking for ways to improve its trade even more, by making slight, smart adjustments.
- Modernizing: At one point or another, every business finds itself in need of a more contemporary identity—or it finds itself falling further and further behind the competition. A fresher look, a more practical design, an aesthetic that better speaks to customers: All of these can be the result of a modernized design.
- Managing Change: Whether a business sees change as good or bad, change will certainly come. If a company's identity refuses to address business change, it becomes more and more irrelevant.

- Promoting Growth: Maybe a business is moving from the realm of precarious start-up to contender status. Perhaps a larger company requires an even larger presence. Promoting growth through a new identity is a bold, tactical move.
- Starting Over: Sometimes an old identity can not or should not be saved. Starting over with a completely new identity is the wisest choice.

But what will the new identity be? What is the new image? Kan Tai-keung, principal of Kan + Lau Design Consultants, one of twenty-five firms whose work is featured on the following pages, offers this explanation, borrowed from an ancient Chinese saying, 'The form is the entity and the entity is the form': "Corporate identity must show undeceivably the inner spirit of the company. Every [business] has its own principles and targets for developing the staff's spirit, the management strategy, the production and services. The overall attitude they adopt to handle such things constitutes a unique corporate culture that distinguishes it from others."

A successful corporate identity, he says, should possess the following qualities: It should be a true image and reflection of the company; it should represent virtuous thinking and behavior; and it should present a beautiful image, both inside and outside the company.

"Our looks speak our minds," says Kan, quoting another saying. "Image is the look. It is a reflection of the true inner self."

A redesigned identity must be a reflection of the company's new inner self. The designer must adopt his or her best Zen persona and not only suggest change because change is construed as good; the designer must be certain that the change is good.

Catharine M. Fishel

REPOSITIONING

—From *Brand Strategy* newsletter, Centaur Publishing, London on brand focus prior to repositioning—

"If the brand is the anchor, all communication must reflect this, both in terms of positioning and core values. Few [businesses], however, follow this through because implementing an integrated approach is an altogether different challenge. And there are a number of reasons why.

"Thinking in boxes can be a major pitfall. Take attitudes to different elements of the communications mix. Many businesses regard advertising as only a distant cousin of brand design and corporate identity—each is regarded as important yet different parts of the equation. So, a client eager to reposition a tired old brand frequently approaches an advertising agency for a new campaign. But in fact the problem is more complex: The packaging looks thirty years out of date. It's no good for the client to then say, 'Let's do the advertising—then look at the design,' [but] many have done so to their own regret."

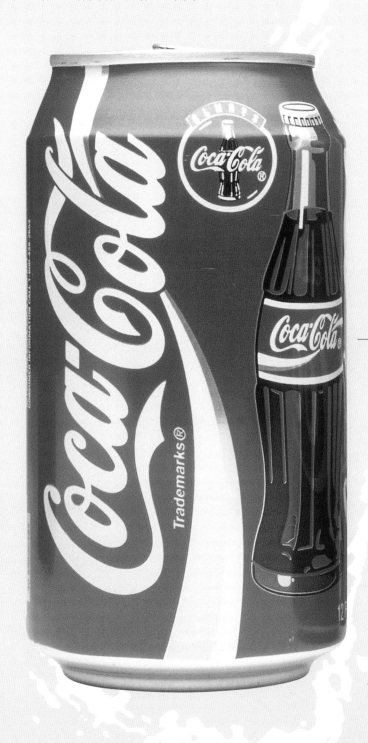

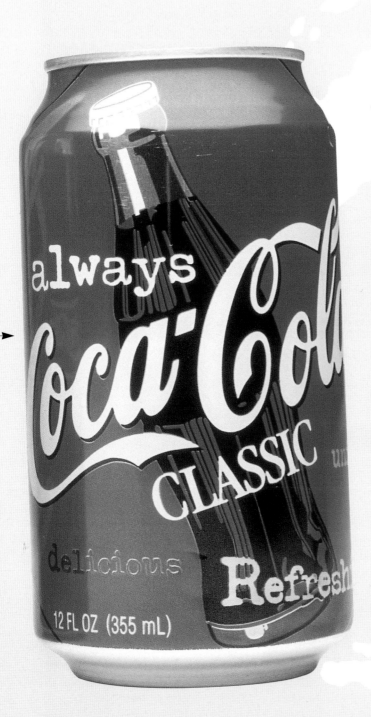

Desgrippes Gobé & Associates for Coca-Cola

Challenge: *When a consumer product becomes so well-known around the globe that it begins to become part of the scenery, it needs a modified identity that re-personalizes the product.*

TRAVEL WHERE YOU WILL, ANYWHERE IN the world, and you will encounter Coca-Cola—on clothes, on signs, on packaging, in art—everywhere. In fact, it has become so ubiquitous that its familiar mark was failing to engage consumers. Coke's identity, company officials feared, had become too familiar.

The equity in its elements is enormous: They could hardly be abandoned. But Marc Gobé and designers at Desgrippes Gobé & Associates, charged by Coca-Cola to create a refreshed design, felt that the swash, the color, the Spencerian script, and familiar icons like the "Always" slogan and button and the contour bottle could be recast in new roles.

"Our strategy was to reach the customer at different levels and at different points," Gobé explains. "The emotional content of Coke changes at different times, different locations and at different situations. If you see a Coke sign at 6 A.M. when you're sleepy and sitting on the train, it does not have the same effect as when you are at a ballgame or at a rock concert, in a better mood. We had to find a way to elevate the emotional message and make it relevant for specific times or events."

The designers began by analyzing the different icons Coke employed—swash, color, script, button and bottle. They discovered that all of the icons

Before and After

Coca-Cola's new identity replaces the old dynamic ribbon element, which has adorned the can since 1969, with elements from the famous contour bottle.

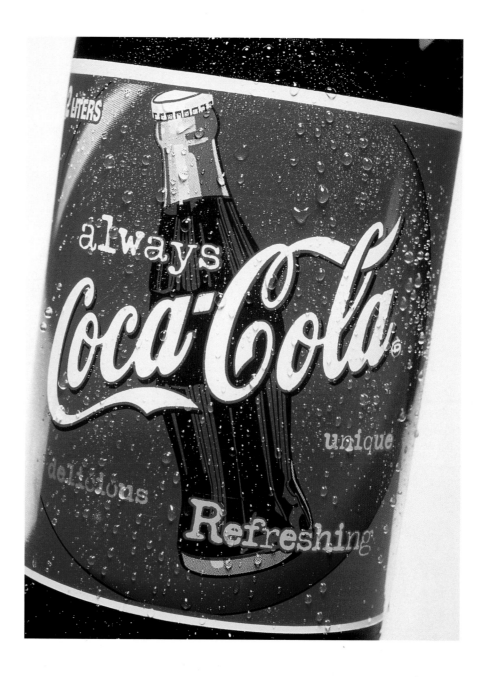

DESIGN FIRM:
Desgrippes Gobé Associates

CREATIVE DIRECTOR:
Peter Levine

ART DIRECTOR:
Lori Yi

except the bottle were used with similar intensity. None stood out. But research showed that some icons interested consumers more than others. Specifically, the bottle shape resonated deeply in terms of nostalgia, refreshment, and instant recognition.

The color red and script type were effective entry points to the identity. "But the contour bottle makes the emotional impact," Gobé says. "Like the Nike swoosh, it has transcended its original meaning to become an icon." Designers found that the word

always and the button also had the right emotional flavor.

By reemphasizing these elements in the new identity design and by removing the swash, Desgrippes Gobé designers leveraged the elements' emotional worth in a fresh, relevant way. Designers added the words *always, delicious, unique,* and *refreshing* to Coca-Cola Classic packaging, and they reintroduced the familiar Coke-bottle green, further detailing the nostalgic bottle.

Coca-Cola tested the concept during the 1996 Olympic Games in Atlanta, Coke's

The new identity was tested at the 1996 Olympic Games in Atlanta. In keeping with Desgrippes Gobé's goal of creating a personalized identity for a global brand, graphics promoted Coke as the drink of fans.

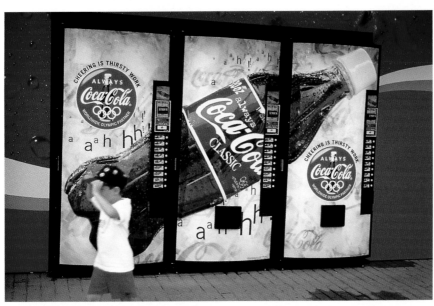

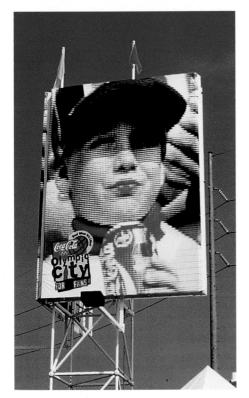

The identity was tested and stretched even further at the World Cup in 1998. The contour bottle shape was isolated and simplified; bubbles graphically suggested the nature of the drink (below).

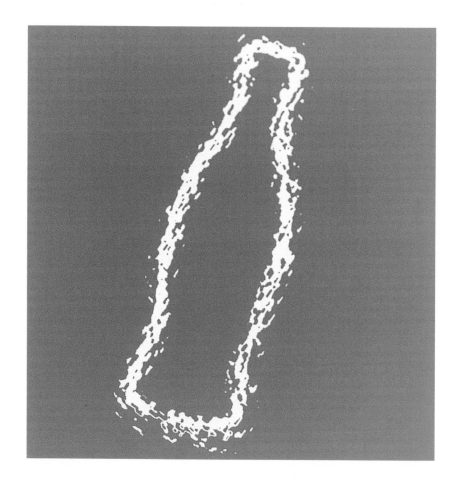

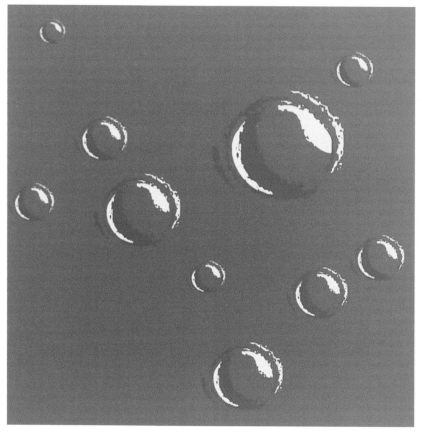

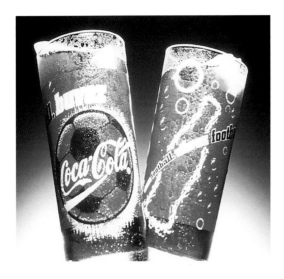

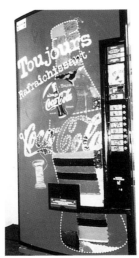

These designs, created for the World Cup in 1998, illustrate the new identity's ability to be customized for specific audiences and events.

stomping grounds. "We didn't try to make Coke the drink of the Olympics, but rather the drink of the Olympics fans—how Coke shared this unique moment and the excitement with them," says Gobé.

The customized-for-the-event approach was enthusiastically received, so the new identity and packaging was adopted. Then for the World Cup games in 1998, Desgrippes Gobé focused even more on the icons. The shape of the bottle used alone sometimes appears as a line only and sometimes as if it were behind glass block. Studies showed that consumers construed this effect as a refreshing look. Sprinkles of bubbles suggested the nature of the drink. The button, converted into a soccer ball, personalized the identity for this event.

The new identity is able to touch customers in more relevant ways. "Coke will be able to handle the logo in a more module way now," Gobé says. "They can be relevant to specific events, for instance. The look is always the same, but it is always different, depending on what they want to communicate."

Even simpler are these designs created for Coke retail stores. The minimal nature of the graphics creates a purer, more modern brand identity, easily recognized and more immediately engaging than the old look.

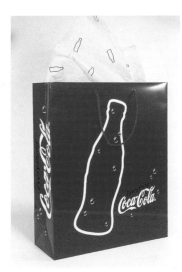

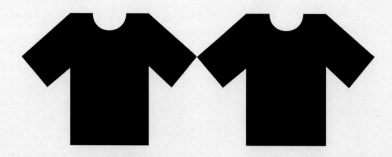

Before
T Shirts De Mexico's original mark
was built from two T-shirts intended
to represent the unisex offerings of
the company. But it wasn't very
memorable, and it could also be read
as an *M*.

Félix Beltrán & Asociados for T Shirts De Mexico

Challenge: A company with an ideal yet less-than-memorable name needs a logo that will differentiate it from the competition.

T Shirts De Mexico SA is exactly what it sounds like—a manufacturer of T-shirts in Mexico. It sells its wares mostly to visitors of Mexican beaches, national and international tourists of every age, looking for souvenirs of their visit.

But its very common name actually worked against its success: The word T-shirt was so common that it simply wasn't memorable. The business owner decided that a logo with impact might make a more lasting impression in consumers' minds.

Félix Beltrán considered his client's original logo. T Shirts De Mexico's garments were unisex, so the old logo used two shirts to represent male and female. But Beltran felt that the unisex aspect indicated that only one shirt should be used.

The old logo's two side-by-side shirts also could be mistakenly read as an *M*, further diluting the identity with irrelevant and unintended information. The *M* effect intensified when the logo was used in smaller sizes, as it often was on labels and tags. Beltrán also felt that the black shirts didn't speak of the company's multicolored offerings and that the typeface used for the company name was too feminine.

Despite the too common nature of the client's name, Beltrán felt he could make T-shirt work in a new way. Understood in both English and Spanish, the word carried too much international equity to abandon. He began to explore graphic possibilities of the *T*, discovering almost immediately that dropping the letter out of a T-shirt shape created a double image, a double impression.

Beltrán liked the mark very much, but his client wasn't so sure. He wanted to try interpreting the neckline of the T-shirt more literally and/or add surface interest to the flat logotype. The designer did experiment with some of these ideas, but in the end, both agreed that the very simple, T-on-T mark was best.

The mark appears in a modern, sans serif typeface for the complete name of the business or other printed information.

"The more brilliant colors, associated with the colors of the United States, worked well because the owner wanted his product to look as though it was imported," Beltrán says. "The applications of the new mark were more coherent and the public interest has been greater."

DESIGN FIRM:
Félix Beltrán + Asociados

ART DIRECTOR:
Félix Beltrán

DESIGNER:
Félix Beltrán

After
The new mark, designed by Félix
Beltrán & Asociados, not only repre-
sented the product graphically, it also
made the most important part of the
company's name more memorable.

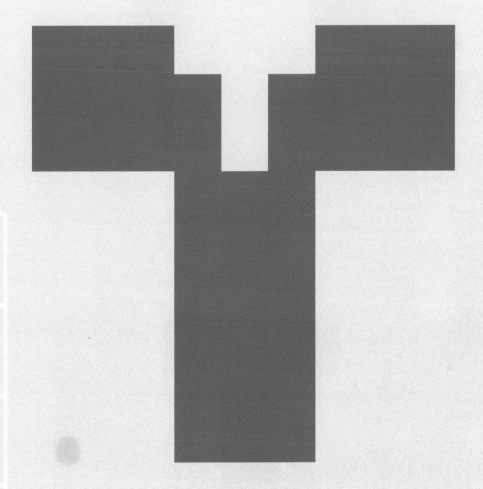

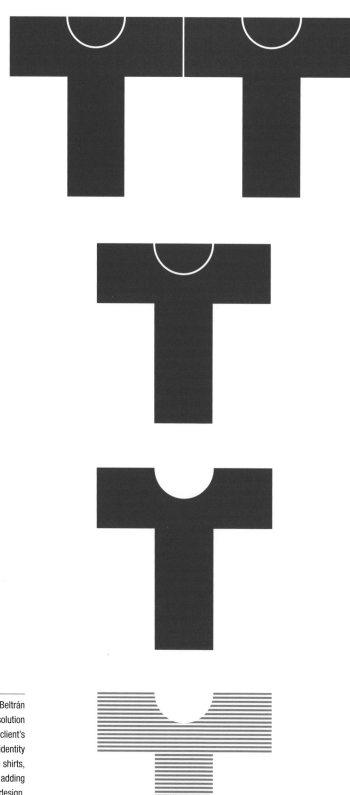

Although designer Félix Beltrán came upon the ultimate solution quickly, he agreed to the client's request to tie into the old identity more closely. But pairing two shirts, using a rounded neckline or adding texture, did not improve the design.

T SHIRTS DE MEXICO SA

ISABEL LA CATOLICA 308
COL OBRERA
MEXICO 06I00 DF
TEL 5224834 FAX 522531I5

Beltrán's selection of red, white, and blue for the system was intentionally very North American: His client wanted his product to look as though it were imported.

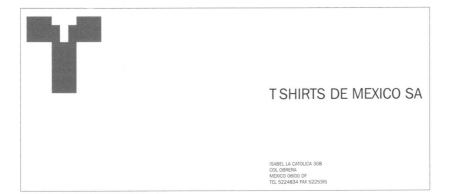

T SHIRTS DE MEXICO SA

ISABEL LA CATOLICA 308
COL OBRERA
MEXICO 06I00 DF
TEL 5224834 FAX 522531I5

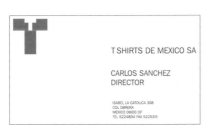

T SHIRTS DE MEXICO SA

CARLOS SANCHEZ
DIRECTOR

ISABEL LA CATOLICA 308
COL OBRERA
MEXICO 06I00 DF
TEL 5224834 FAX 522531I5

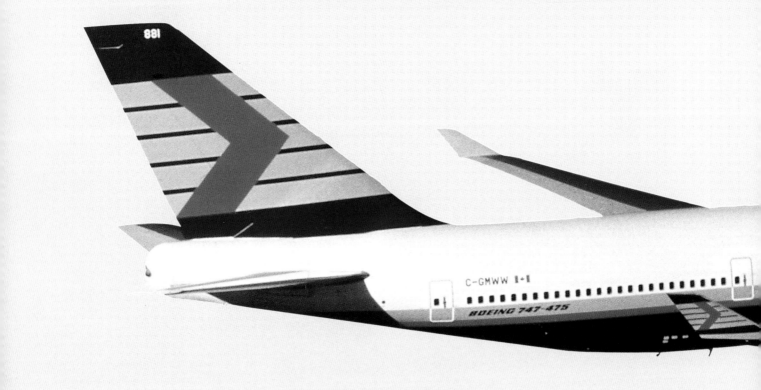

Before
Canadian Airlines' original identity
was outdated and unremarkable. In
addition, a boxed-in motion mark
interrupted the company's name. To
attract the savvy business traveler, a
more dynamic look was needed.

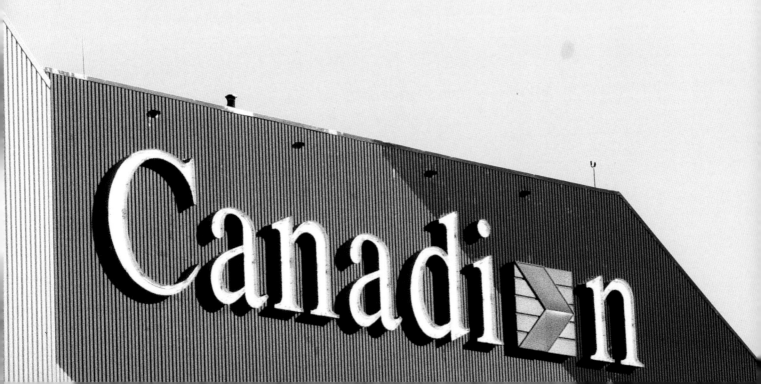

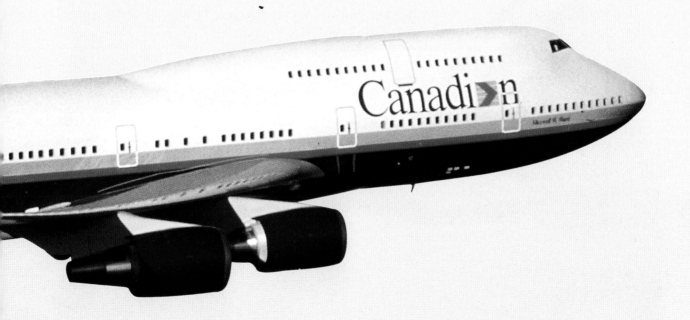

Landor Associates for Canadian Airlines

Challenge: *To capture the business-traveler market, an airline needed an identity with a savvier, more energetic personality.*

PERHAPS THE MOST SWEEPING PROGRAM featured in this book, Canadian Airlines' identity redesign by Landor Associates reaches customers through an estimated 1,900 touch-points. From in-flight playing cards to enormous airplanes and hangers, the new identity was developed to reposition the airline so that it could better pursue its target audience, the business traveler.

The previous identity did not accurately or consistently represent Canadian's energy, innovation, and professionalism. A red arrow within a gray square replaced the final *a* in the Canadian word-mark, but the motion mark was made static by a box-like frame, an effect that did not make much sense for an airline. The boxed arrow also interrupted reading.

The manner in which the graphics were applied was also problematic. "Canadian's red and blue colors weren't managed uniformly, and in some cases, had become faded," says Landor project manager Bill

Larsen. "The inconsistency diluted the airline's vibrancy, which left planes and other applications looking dated."

Following months of extensive research with hundreds of airline employees and customers, Landor recommended enlivening Canadian's entire identity system to attract the attention of the savvy business traveler. Canadian Airlines had significant equity, as it related directly to the universal respect the country commands. The red, white, and blue scheme also had value, so the colors were immediately cleaned up. A new, deeper blue and a brighter, warmer red provided a more dynamic, modern feel.

Removing the box from the motion mark as well as streamlining it made it more of a letterform and less of an intrusive logo. Finally, running the entire name in the new, clearer red using the typeface Celeste—a stable, but energetic face—completed the new wordmark.

From there, Landor began exploring how

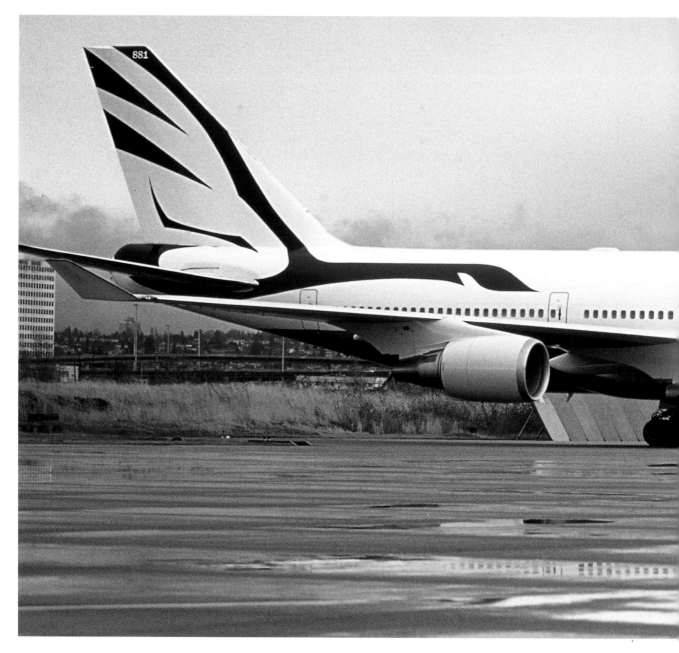

the new identity could be applied to hundreds of customer touch-points. One of the largest and certainly most noticeable applications was the Proud Wings graphic on the sides of the airplanes. Applying the identity art to the aircraft stabilizer and fuselage in a larger-than-life manner turned the one-dimensional icon into an attention-grabbing, three-dimensional graphic across the aircraft.

Another super-scale application appears on Canadian's Calgary hanger. Outlined in red neon, twenty-four-foot-high letters and a sixty-foot-high goose greet every plane and car that enters the airport. Further applica-

tions can be seen everywhere else: on airport and facility signing, aircraft interiors, in-flight literature, corporate stationery, and much more.

The redesign project has been in motion for about eighteen months. Implementation began in early 1999 and will continue for up to five years. The client already has seen its desired market share increase, and its overall bookings have begun to run at capacity.

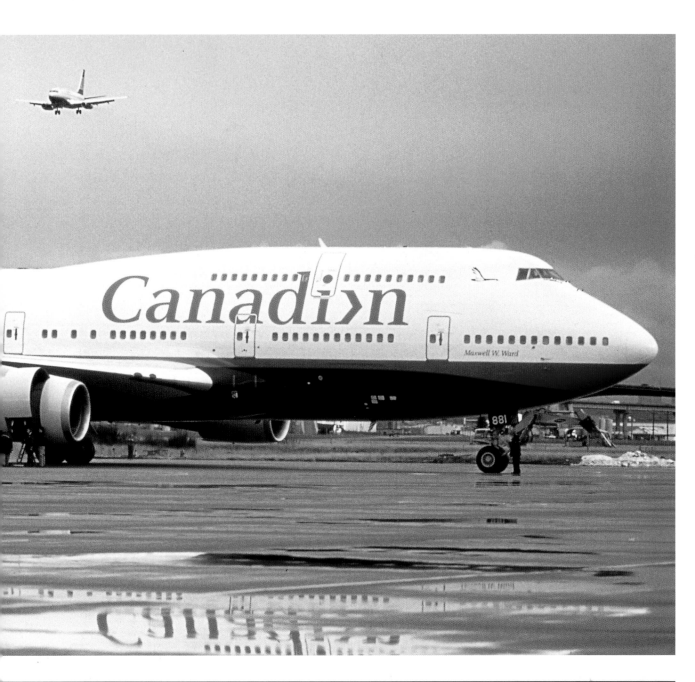

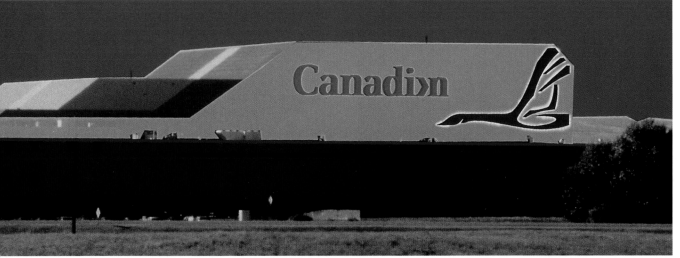

From luggage tags and in-flight literature to lounges and support vehicles, the new identity has been worked into Canadian Airlines' business across the board.

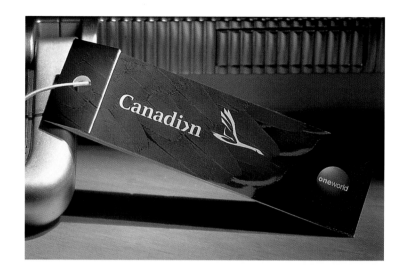

DESIGN FIRM:
Landor Associates

EXECUTIVE CREATIVE DIRECTOR:
Courtney Reeser

CREATIVE DIRECTOR:
Scott Drummond

SENIOR CONSULTANT, STRATEGY:
Alton Wright

CODESIGN DIRECTOR, IDENTITY:
Paul Chock

CODESIGN DIRECTOR, ENVIRONMENTS:
David Zapata

CREATIVE DIRECTOR, PRINT:
Nancy Hoefig

SENIOR PROJECT MANAGER:
Bill Larsen

DESIGNER, IDENTITY, LIVERY DESIGNS:
Todd True

DESIGNERS, AIRCRAFT INTERIORS AND IN-FLIGHT PRODUCTS:
Joanna Bianchi Martinko, Birgit Igel

DESIGNER, FACILITY INTERIORS:
Kerry Findlay

DESIGNERS, SIGNAGE:
Ivan Thelin Martinko, Garrett Chow

DESIGNERS, IN-FLIGHT PRODUCTS:
Carlyn Ross Martinko

DESIGNERS, PRINT:
John Martinko, Maria Wenzel

IMPLEMENTATION DIRECTOR:
Russell DeHaven

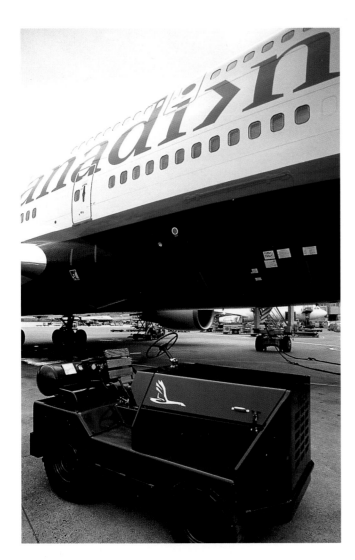

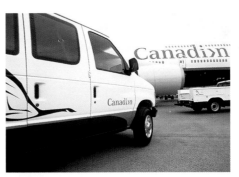

Before
When Malt-O-Meal launched its line
of cold cereals, consumers did not
perceive the bagged product as hav-
ing the same quality as other brands
of more expensive boxed cereals.

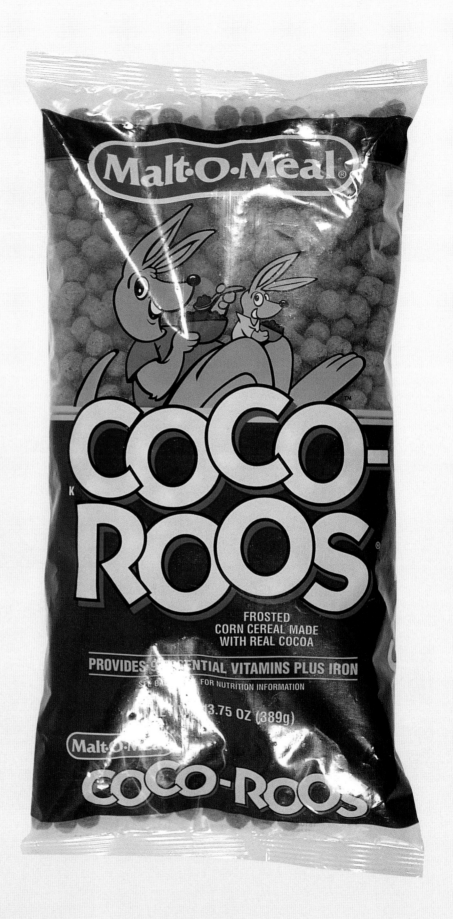

After
Murrie Lienhart Rysner's new identity for Malt-O-Meal has a more contemporary, quality feel, plus it speaks of freshness and nutrition.

Murrie Lienhart Rysner & Associates for Malt-O-Meal

Challenge: An offshoot product of a long-standing, very popular brand needs to develop its own identity in order to stand out and be more competitive.

MALT-O-MEAL HAS MAINTAINED ITS wholesome identity with such single-mindedness over many years that the brand name has become synonymous with the product: Both the name and the hot cereal evoke a real sense of warmth. So when the company launched a new line of cold cereals, it faced a peculiar challenge: The new cereals were packaged in flexographically printed bags that made them much more economical to produce and buy than boxed cereals. But despite the price break and the fact that the products were every bit as good as those produced by Post, Kellogg's, and other competitors, consumers felt the bagged cereals did not offer comparable quality. Applying the Malt-O-Meal branding "as is" to the cold cereals made the look of new products seem old-fashioned.

When Malt-O-Meal contacted Murrie Lienhart Rysner & Associates for advice, the company was searching for a way to maintain the original identity for the hot cereal and create a more progressive, high-quality image for the twenty SKUs in the new product line.

Complicating the puzzle, the new identity would have to work on packaging for kids' cereals, adult cereals, and family cereals. "What we created had to have a strong umbrella identity," recalls Principal Jim Lienhart. "But each product had to have its own identity as well. We needed a way to individualize each unit and still have character for the whole line."

Lienhart's designers knew that the red background color in the hot cereal logo had a lot of equity on the store shelf, so that element would remain constant. They began by

DESIGN FIRM:
Murrie Lienhart Rysner & Associates

CREATIVE TEAM:
Jim Lienhart, Linda Voll, Annette Ohlsen, Julie Winieski, Lou Izaguirre, Amy McGrath

ACCOUNT TEAM:
Herb Murrie, Karen Schwartz

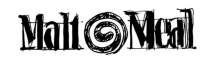

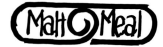

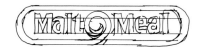

The *O* at the center of the brand name presented many opportunities for experimentation. On these trials it becomes a "flavor swirl."

Working a heart into the design referenced the nostalgia inherent in the Malt-O-Meal's brand, plus it implied caring and motherly love.

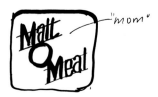

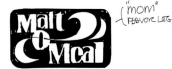

By happy accident, the initial letters in Malt-O-Meal form the word *MOM*. These comps tried to bring this element to the forefront.

experimenting with lettering to convey the wholesome Malt-O-Meal identity in new ways. Trials ranged from playing with healthy, natural images like suns and grains, quality crests, hearts, flavor swirls, taste icons like spoons and bowls, and the initials *M-O-M* to evoke the brand's main champions, mothers looking for nutritious foods at a reasonable cost.

Personalizing the brand was key. "I try not to think of the thousands of people buying the product," Lienhart says. "I think of it personally and try to keep it as human and emotional as possible. I want to make it feel as if it's right for you."

After comps were presented to the client, sun imagery emerged as a favorite, but other ideas weren't abandoned. The *M-O-M* note still appears in the final design, and a grain element weaves through it. All-script lettering may have been too elegant for the kid cereals, and cartoonish type would have been wrong for adult cereals. But rendering the words in a typeface with personality and tucking a scripty *O* at the center of the mark had just the right flavor. To individualize each product in the line, cartoon figures cavort on color backgrounds of children's varieties, but color without cartoons differentiates other cereals from one another.

"I think we gave them an original identity with a connection to tradition. It has a contemporary typeface but is easy to read. It has that original touch of handmade art for warmth," Lienhart says.

The designer notes that he used to believe that when he created an identity for a product, he could go in a completely opposite design direction from other products in the existing category—for instance an embossed, all-white box for soap. But now he feels that for consumers to trust the new product, it's important to recognize and acknowledge their preexisting perceptions about the category. Soaps sold on the retail shelves generally have a very bold presence, to continue with the analogy. An all-white box might not even be perceived as soap.

"You have to find what is unique about the product and bring it into the imagery," Lienhart adds.

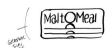
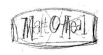
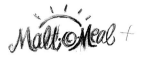

Good health is implied by the sun imagery in these sketches. Again, the *O* presents a logical slot for artwork.

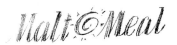
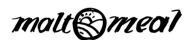

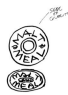

Because the cold cereal's perceived quality among consumers wasn't adequate, Murrie Lienhart Rysner designers created a number of quality-seal elements.

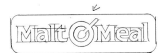

These sketches explored the cereals' taste appeal through images of spoon, bowls, and smiling mouths.

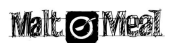

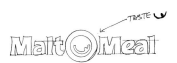
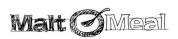

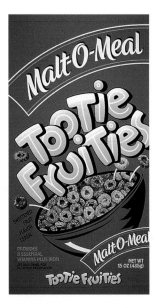
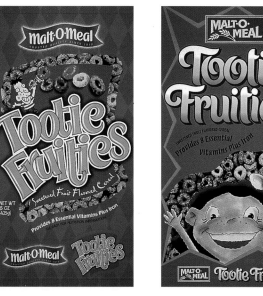
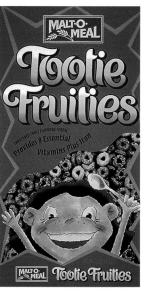

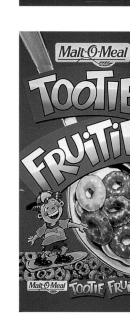

A range of color comps ultimately
was presented to the client.

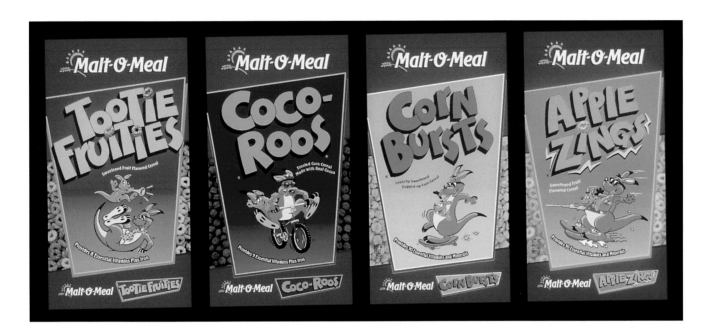

The final solution applied to a selection of children's cereals preserves the background red from the original identity. But Murrie Lienhart Rysner designers made it much richer, another quality reference.

The reversed version of the mark—dark type on light background—is applied to letterhead, business cards, envelopes, and other "white" printed items.

Turner Ducksworth for Steel Reserve Beer

Challenge: A new lager with an elegant identity is received well in test marketing, but no one is quite sure what to call it.

THERE'S NO DENYING THAT MALT LIQUORS have a bad reputation in the United States. Brewers of these high-alcohol beers are accused of exploiting those who simply want to get intoxicated—fast. So when the Steel Brewing Company decided to launch a high-alcohol brand that was brewed for taste, not a quick buzz, it wanted a higher-end look. Toward that end, its initial label design was an elegant, nearly all-black design, emblazoned with a mysterious, swashy red sign, an ancient symbol for steel.

Although test marketing showed favorable reception of the product and identity, the Steel Brewing Company owner felt that his new product didn't have any particular positioning. He approached David Turner of Turner Ducksworth for advice.

"My first comment was that it was a shame that you didn't know what it was called," Turner recalls. The swashy symbol overpowered the brew's moniker to such a degree that its young, hip target consumers were actually beginning to call it "211." When the owner coined the phrase, "high-gravity lager" as an alternative to the less appealing "malt liquor," Turner knew he had what he calls a "single-minded" design approach.

"We liked the phrase because it expressed strength without saying 'strong,' which you are not allowed to say on the packaging," Turner says. So he began exploring visual approaches that said the same thing. He began by thinking about imagery that expressed strength as it related to steel. Several trials explored forming wheat into a buzz-saw blade, an idea that Turner liked. But this design did not include the 211/steel symbol, which everyone agreed had achieved a kind of accidental equity and should be preserved. But the mark had to be much more readable in order to be included. Simplifying its strokes set the designer in a new direction—an industrial look that was good match for the "high-gravity lager" tagline and "steel." Turner studied warning and industrial signs for inspiration. Adopting this look for a food or drink product can be a

tricky thing, Turner says. "If it looks like a can of gasoline, you won't consider putting it in your body," he adds.

So the designer concentrated on creating a much more refined aesthetic in the design than found on warning signs. Elegant letter- and line spacing, surrounded by plenty of white space, created a quality look that also conveyed a sense of cool refreshment. The open spacing also allowed the foil substrate of the bottles' labels to show through, again underlining the "steel" element of the design. The six-pack holder has the same industrial feel: Instead of printing on the white side of the chipboard, Turner utilized the kraft paper side. Printing silver ink on the brown stock provided just the right amount of metal. The short bottles were important to the brand's identity and tied into another offering in the brewer's line, Howling Monkey, which also was packaged in a strong, stubby bottle. Both beers can be produced on the same bottling machinery. "We felt this was the right feel for a potent drink," Turner says.

The identity was applied to other pieces as well, including a tall, steely can, case packaging, "warning" signs, T-shirts, trucks, the Steel Brewing Company's Web site, and even hard hats. "All of the materials look serious," Turner says, "but on closer inspection, you can see that it's really all just for fun." The new brand identity, highly praised by the design community and by consumers, results from how San Francisco-based Turner and his partner Bruce Ducksworth work together. "We want a design that is single-minded," he says. "We always collaborate. This project went back and forth across the Atlantic a number of times. If one designer starts to stray away from the single idea, the other designer brings him back. The single idea here was 'industrial strength.'"

This has become such a popular urban brand, Turner says, that the brewer can't make enough of it.

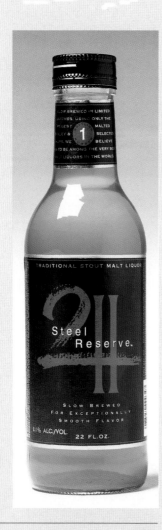

Before
When the Steel Reserve lager was test marketed with this label and a corresponding identity system, it did well. Trouble was, no one knew what to call the brew: Steel Reserve, 211, or even 2H.

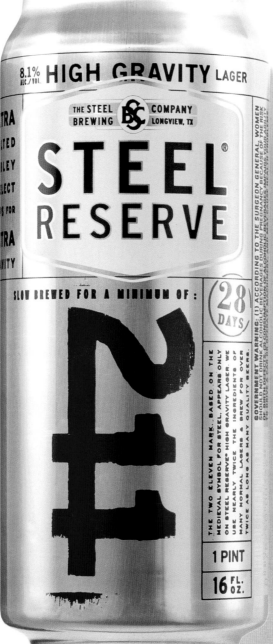

After

The Steel Reserve name was made more prominent, and the 211 element—actually an ancient symbol for steel—was turned on its ear, transforming the mark into art, rather than something that should be read. The silver of the aluminum can and other industrial cues work off of the brew's name.

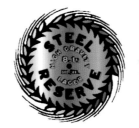

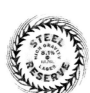
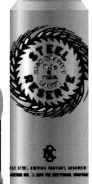
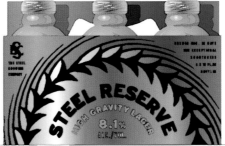

HIGH GRAVITY

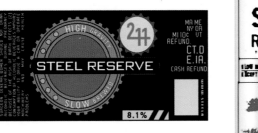

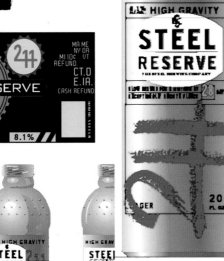

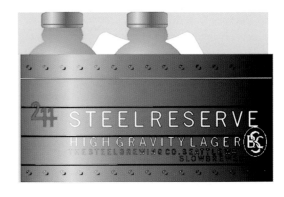

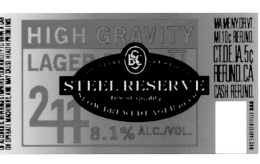

This collage of trial comps shows a range of very different imagery. Principal David Turner says that his firm prefers to present clients with a number of ideas that he believes are workable rather than one, pristine, ultimate design. "When a client can choose amongst a number of good ideas, they know they have picked the best one," he says.

DESIGN FIRM:
Turner Ducksworth

ART DIRECTORS:
David Turner, Bruce Ducksworth

DESIGNERS:
David Turner, Allen Raulet

After the client suggested using *high-gravity lager* on the label instead of *malt liquor* or *malt beverage,* Turner envisioned a more single-minded direction: an industrial, steely identity that looked serious but had an underlying flow of fun. This collection of industrial images helped the designers set the direction.

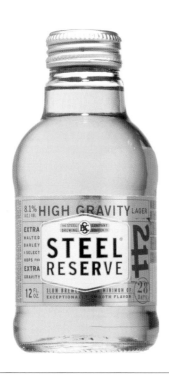

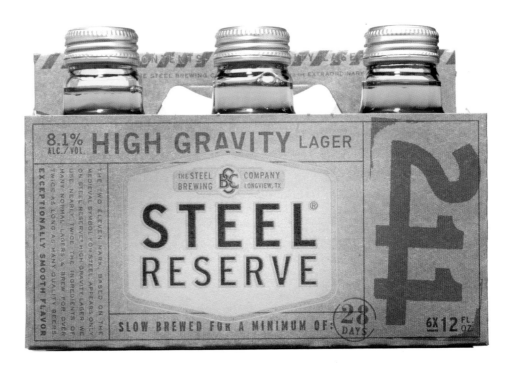

Letting the silver foil of the label show through on the bottles' labels served as a ready visual reminder of the brand's steely identity. Stout, stubby bottles also communicated a feeling of industrial strength, as did the six-pack holder. The kraft paper side of chipboard was printed with silver ink, creating just enough of a metallic glint.

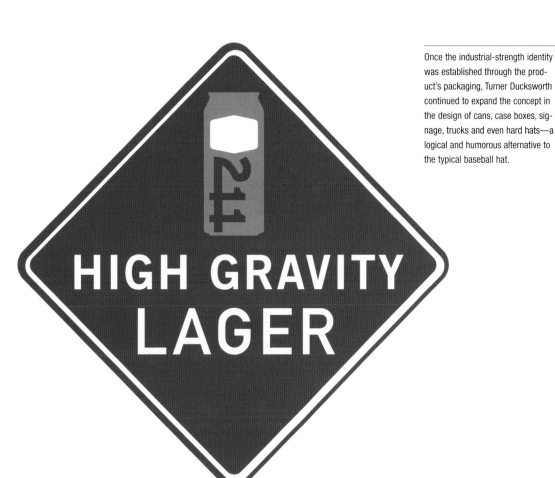

HIGH GRAVITY LAGER

Once the industrial-strength identity was established through the product's packaging, Turner Ducksworth continued to expand the concept in the design of cans, case boxes, signage, trucks and even hard hats—a logical and humorous alternative to the typical baseball hat.

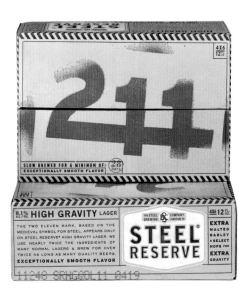

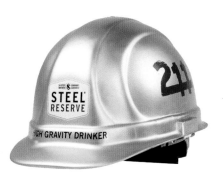

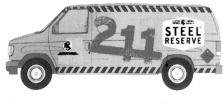

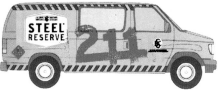

MODERNIZING

—MARY K. BAUMANN OF HOPKINS BAUMANN ON BRANDING AND MODERNIZING—

"When I was an art director at Time, Inc., the company was trying to develop a new magazine called *Picture Week*. All of the guys working on the project thought it would be a dual audience, male/female magazine that would be news-oriented. That told me what kind of look it should have."

"But then I took a field trip to where it was going to be sold—at the grocery store check-out. It was then that I thought: 'Guys aren't going to buy this. Women are going to buy it. This needs a completely different package.' This lesson has always stuck with me."

"A publication needs a package, just like Cheerios or Dove soap does. With magazines, we really try to offer some kind of real identity in the logo or nameplate. A lot of people are talking about branding nowadays. But they don't think of it in terms of visualness. A lot of publications don't have a good visual identity. There are the venerable names in publications, like *Time* or *Life,* that have identity because they have been around a long time. But to be new on the block and achieve visual equity—you have to do something completely different."

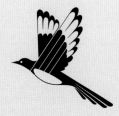

Before

The original symbol and "mascot" for the old, Korean government-owned Kookmin bank were based on traditional symbols—a four-leaf clover and a magpie—but they just underlined the bank's outdated look.

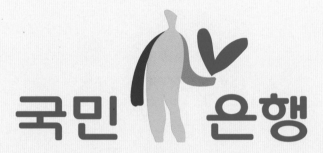

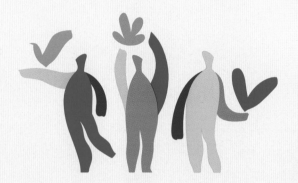

Design Park for Kookmin Bank

Challenge: A large bank needs a friendlier image when ownership shifts from the government to the private sector.

When the Korean government decided to privatize many industries in its country, organizations like the Kookmin Bank were faced with an interesting challenge. Kookmin Bank—literally, "nation people" or citizen's bank—was seen as bureaucratic, outdated, and not particularly interested in serving individual consumers. A more modern identity was a must, or else the bank might not survive in the new privatized environment.

The old identity included a magpie, an auspicious symbol in Korea known as the harbinger of good news. Another portion of the mark was a cluster of ovals, meant to convey the good luck of a four-leaf clover. Traditional symbols, however, seemed to reinforce the image of an outdated institution, says Hyun Kim, principal of Design Park, the agency that undertook redesigning Kookmin's identity. "The bank wanted an image that was both gentler and friendlier," Kim says. "It decided to take the occasion of privatization to build an image of a bright,

friendly bank and demonstrate its changed nature."

Design Park designers considered numerous possibilities based on surveys conducted within and outside of the company. Because the meaning of the bank's name refers to all Koreans, they ultimately decided to center the theme on the subject of people. According to Kim, "This reflected the new corporate philosophy of giving top priority to consumers."

The main symbol Design Park developed is a person with a heart-shaped leaf in hand to project the hope, care, and financial growth that the bank helps to provide. Other characters holding other lively symbols such as flowers and birds were developed to use for other occasions. Green is the main color; blue, red, and yellow supplement the feeling of active growth. Modern Korean and English faces match the personality of the new characters.

The new identity received a very favorable

DESIGN FIRM:
Design Park

CREATIVE DIRECTOR:
Hyun Kim

ART DIRECTOR:
Eenbo Sim

DESIGNERS:
Keunmin Son, Young Chai, Yongkyu Chun, Hankyung Chung

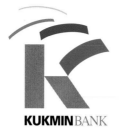

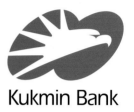

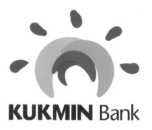

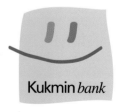

Design Park's sketches explored
human themes, searching for a way
to suggest life and energy.

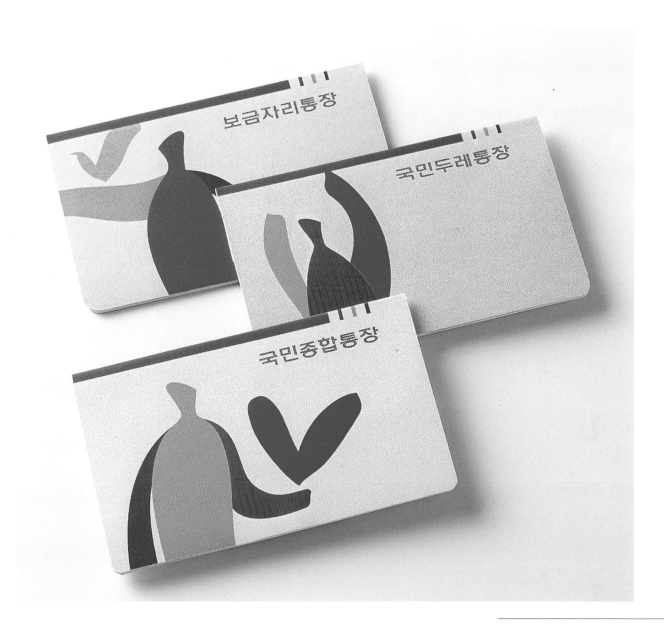

Bank books feature new corporate
caricatures.

Combining the characters with a bright, vibrant green suggests freshness. The image projects the bank's new strategies: The importance of the customer, convenience, and responsibility for the customer's financial future.

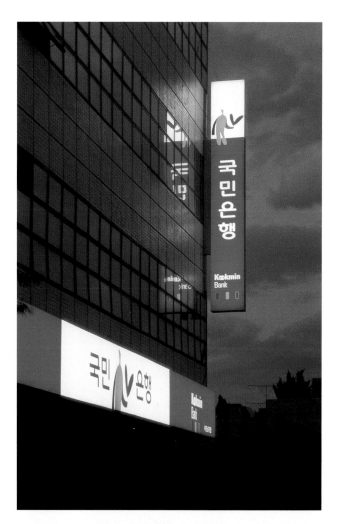

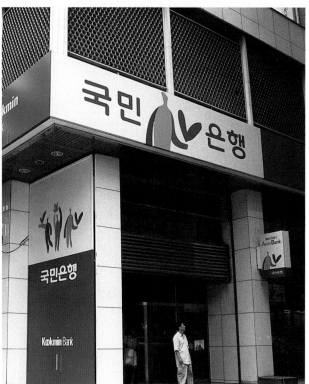

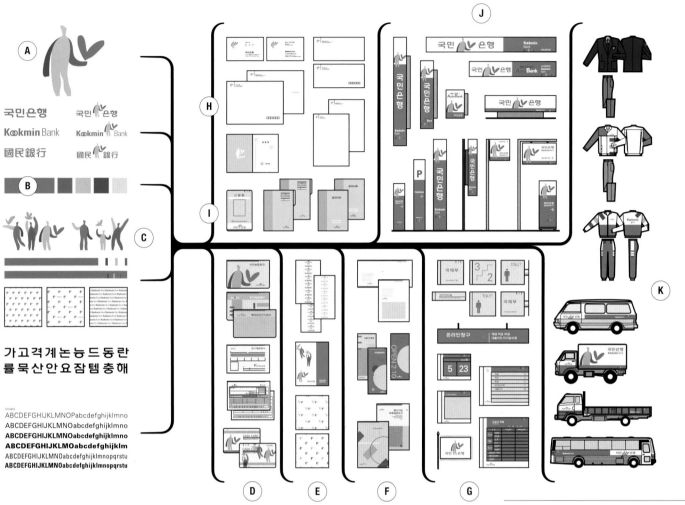

This chart shows the full range of the new Kookmin identity system.

A. Basic patterns used for documents and wrapping people
B. Color palette
C. Various characters; can be used alone or together for different occasions
D. Bank account passbooks
E. Wrapping papers
F. Cover formats for publications
G. Indoor signage
H. Various documents
I. Various forms
J. Outdoor signage
K. Uniforms and vehicles

able response from consumers and bank employees. But it was rejected by older managers, the very people who would have to give Design Park the OK to proceed with the design.

"We had considerable difficulty in convincing the bank at first," Kim says, "but we succeeded by stressing the results of our surveys, which indicated that the future clients of the bank, the young and women, gave the new identity high points." The bank managers made the right choice by granting their approval: The number of passbook holders, deposits and profits have all grown, as has the bank's reputation as a friendly, stable, reliable organization. In fact, a national consumer group ultimately selected the bank as "the best bank."

Hopkins Baumann for
Step-By-Step Graphics

Challenge: *A magazine searching for a new nameplate finds that it needs a completely new identity.*

THE IDENTITY REDESIGN OF *STEP-BY-STEP Graphics* magazine is the most extended project featured in this book. In fact, if records for such things were kept, designers at Hopkins Baumann would have earned a special prize for patience: Their original redesigns were submitted to the magazine staff in 1992, but the new look wasn't formally adopted until 1997—and the reworking continues today.

When Will Hopkins and Mary K. Baumann of Hopkins Baumann were called in to rework *Step-By-Step*'s identity, the magazine's logo had remained unchanged for seven years. "We felt the logo looked heavy and dated. But it was unobtrusive," says editor-in-chief Talitha Harper. "Since we were producing these poster-like covers, we were reluctant to brand the magazine with a real logo." Mary K. Baumann also felt that the old logo looked dated and a little fussy. "It was difficult to tell one issue from the next," she adds. "We also thought it was too conservative for the audience."

What wasn't wrong was the magazine's content, Baumann says: That was excellent. Sometimes publications with poor content

Before

In the old design, the nameplate/logo was used on the cover as well as on story openers inside. But instead of serving as an effective visual start-here signal, its overuse quickly turned it into wallpaper.

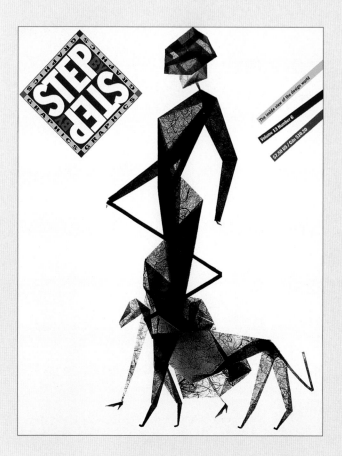

After

The new logo appears only on the
cover of the magazine, but its
personality is felt on inside pages
as well.

will approach her firm for a redesign, believing that will fix everything.

Joseph Lee, the designer who created the new mark, began by considering the long, unwieldy name. He expanded the name across the top of the cover, a move that instantly would increase the brand's presence on the newsstand. But no matter what he did with the type, it didn't have the kind of immediately identifiable look that it needed.

Best, thought Lee, might be to turn the typography into an actual logo: This not only would shorten the title, it also would be more recognizable on the newsstand. Stacking and restacking the type, Lee puzzled the pieces together until he saw that the repeating words might be an advantage for him: They could by assembled into a compact yin-yang fashion to create a self-contained logo that could float

Hopkins Baumann explored other name-plate looks for *Step-By-Step*, but these still didn't have the recognizable shape and feel of brand identity.

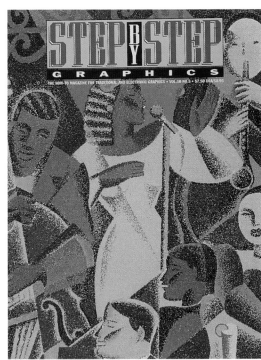

When the designers devised the repeating step-by-step-by-step-by … cube, they knew the identity would have both newsstand presence and sub-scriber appeal. Turning the cube onto a corner and letting the word *graphics* repeat gave the mark a more dynamic feel.

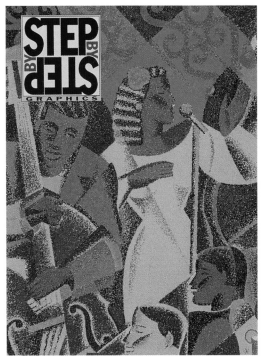

anywhere on the magazine's cover. Setting the logo on its corner gave it motion.

"This is a magazine all about steps. You could have two steps, or three steps, or fifteen steps, and the logo will continue to read 'step-by-step-by-step-by-step.' It's like an infinity symbol," Lee says. He selected bold, modern type so that it had the same impact as a bullet or a boldface number in a list of instructions.

When the new mark was presented to the *Step-By-Step* staff, even though the design staff was ready to move with it, the then-editorial staff was unsure. So the presentation boards were relegated to the flat files, where they languished until Harper and art director Mike Ulrich took over the helm.

The previous staff had viewed the new

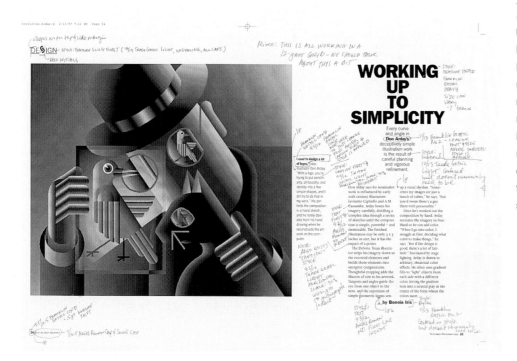

logo as a cover treatment. The new staff was ready for a complete overhaul inside and out that opened up more opportunities for design. So they brought out the Hopkins Baumann boards again and contacted the designers, who then began to recast the entire publication, a process that took nearly a year.

Art director Ulrich says that the major change, the one that affected the publication's identity most, was eliminating *Step-By-Step*'s textbook look. Toward that end, each spread is now considered separately and not just as part of a strict and never-ending grid. Headlines can be manipulated in a number of ways; body text is reduced, and more space is made available for captions.

The overall effect is that *Step-By-Step* now looks like what it is: a publication for professional designers, not a primer for entry-level students.

"Now people see the logo on the newsstand and they are encouraged to pick up the magazine. The cover image makes them want to look inside, and the inside design and content makes them want to buy it," Ulrich explains.

Openers for articles are one of the most noticeable changes in the redesigned magazine. Each article's opener sets the tone and direction for the following pages, which pick up on the flavor of the opener while still relating to the magazine's overall feel.

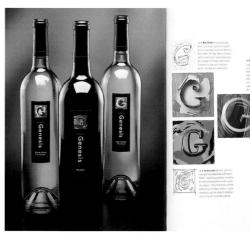

A big plus of the redesign is that type—especially headlines—can follow the lead of the many different kinds of art that appear in the publication. Layouts may be quirky and fun or they can be structured and elegant, but the identity is evident either way.

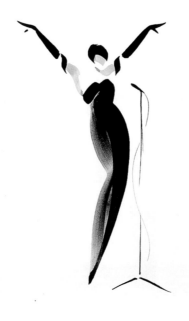

lyric minimalism

French illustrator
Michel Canetti demands
a great deal of himself every time
he picks up a brush: Each line
he draws must epitomize beauty,
simplicity, and energy.

No matter their medium or subject matter, most artists strive to create expressive linework. But how many purposefully limit themselves to as few lines as possible?

Michel Canetti is one. "I want to have only the lines that are important — only what's necessary for the image," he says. "When you can understand the painting with just a few lines, it's not necessary to put in another one. The more lines, the less impact. For impact there should be simplicity."

But simplicity isn't Canetti's only criteria. He also insists that his line lines must be beautiful. "I try for each movement to be elegant," says Canetti. "I always do something with elegance. Even if it is a tragic or a bad subject, you can do the line with elegance. I think elegance is beauty."

FINDING A PERSONAL STYLE

Since the mid-1980s, Canetti has made a name for himself creating illustrations for haute couture houses like Chanel and Dior. but he didn't start out doing sleek, sexy illustrations that personify Parisian chic. During summers as a student at the Sorbonne in Paris and for two years after graduating in 1978 with a double major in graphic design and painting restoration, Canetti designed sets for Club Med nightclubs in such places as Morocco, Senegal, Tahiti, and Tunisia. "There is a show every night," says the illustrator. "I had to do everything — design and paint the memory, furniture, even the trains — very quickly. It was a good experience to work very fast and so intensely. No time for details. You go directly to the essentials."

by Susan E. Davis

Canetti created a series of illustrations for the German hotel chain Arabella. This singer was used to promote the chain's nightclubs.

The redesign of *Step-By-Step Graphics'* identity is a work in progress: With each issue, art director Mike Ulrich finds new ways to push the design.

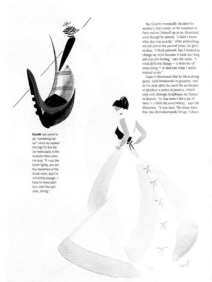

Canetti was asked to do "something Italian" when he created this logo for the Italian restaurants in the Arabella hotel chain. He says, "If I use the brush lightly, you see the movement of the brush more, but if is not strong enough, I have to make each line, even the light ones, strong."

But Canetti eventually decided he needed a real career, so he returned to Paris and set himself up as an illustrator, even though he wasn't sure exactly what that was exactly." After airbrushing record covers for several years, he grew restless. "I liked airbrush, but I wanted to change my style because it took too long and was too boring," says the artist. "I tried different things — a little bit of everything — to find out what I really wanted to do."

Canetti discovered that he liked doing quick, bold brushwork in gouache, and in the mid-1980s he used the technique to produce a series of posters, which sold well through Graphique de France in Boston. "At that time I did a lot of lines — a little bit everywhere," says the illustrator. "It was nice. The lines were fine, but then afterwards I'd say, 'I don't

need all these lines.' So more and more, I used less and less lines. Finally, I decided to keep only the lines that are necessary. I don't know why. This style is more personal for me than airbrush. I feel confident with it."

The evolution of his style took several years, but Canetti gradually built up a new portfolio that featured his smooth, flowing brushwork. And he began producing editorial illustrations for *Elle* and *Vogue* in France, as well as many other fashion magazines in Europe and Australia. While specializing in advertising for women's fashion and beauty products, he's created packaging for Estée Lauder, Helene Curtis, and L'Oréal; he's also done a wide range of work for such businesses as Crédit Lyonnais (France's largest bank), De Beers, Fiat, Louis Vuitton, Lux, Perrier, Renault, Rolex, Waterman, and

For the French edition of *Elle*, Canetti illustrated a 1996 article about the relationship between men and women. "The article said women are not so kind, but men are not so bad, so I wanted her to kiss him a little bit," says the artist.

→ **Projecting an** aura of Parisian chic, this lady in a ball gown was one of a series of 18 illustrations Canetti created for a major promotional campaign targeted to Neiman Marcus VIP customers.

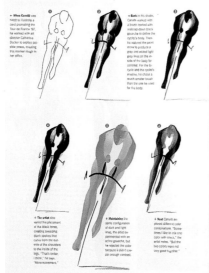

→ **When Canetti** was hired to illustrate a card promoting the Tour de France '97, he worked with art director Catherine Ducher to explore possible poses, creating this marker rough in her office.

→ **Back** in his studio, Canetti worked with a brush loaded with reduced-down black gouache to define the cyclist's body. Then his watered the paint more to produce a gray and added light gray lines on the inside of the body for contrast. For the body and the cyclist's analysis, he chose a much smaller brush than the one he used for the body.

→ **After several** more color experiments, the artist went with a combination of a deep, warm brown and black. The illustration was printed on a card and distributed by the thousands in the cities and towns along the Tour de France route.

← **The artist** also varied the placement of the black tones, creating sweeping black spokes that curve from the outside of the shoulders to the inside of the legs. "That's better, I think," he says. "More movement."

← **Maintaining** the same configuration of dark and light lines, the artist experimented with an active gouache, but he rejected the color because it didn't create enough contrast.

← **Next** Canetti explored different color combinations. "Sometimes I like to mix one color with black," the artist notes. "But the two colors were not very good together."

ONGOING EVOLUTION

Although he's happy with the fluid illustration style he's developed, Canetti continually strives to perfect his technique. "I think you have to improve yourself and be better day after day. If not, you have to stop," he says. "I think I get better, but sometimes when I look at some drawings from many years ago, I say, 'Oh, it was good, too.' I'm not like people who say, 'It's bad so I have to do better.' I prefer to think what I did is good, but I want to do better — I always want to do my best."

Notes Canetti, "I want to change my style again because I always want to allow myself to change." And he jokingly adds, "Over the years, I use less and less lines. Perhaps in a few years, there will not be any."

The artist's personal life is in flux as well. In June, shortly after completing the Tour de France project, Canetti relocated to Victoria, Australia, to be near his 3-year-old son. (Canetti ex-wife is Australian — they met at Club Med — and they decided to move to Australia after five years in Paris.) Thanks to express mail, Canetti plans to continue working for clients in Europe and the U.S., while building a new client base in Australia.

DESIGN FIRM:

Hopkins Baumann

ART DIRECTORS:

Mary K. Baumann, Will Hopkins,
Michael Ulrich (*Step-By-Step Graphics*)

DESIGNER:

Joseph Lee

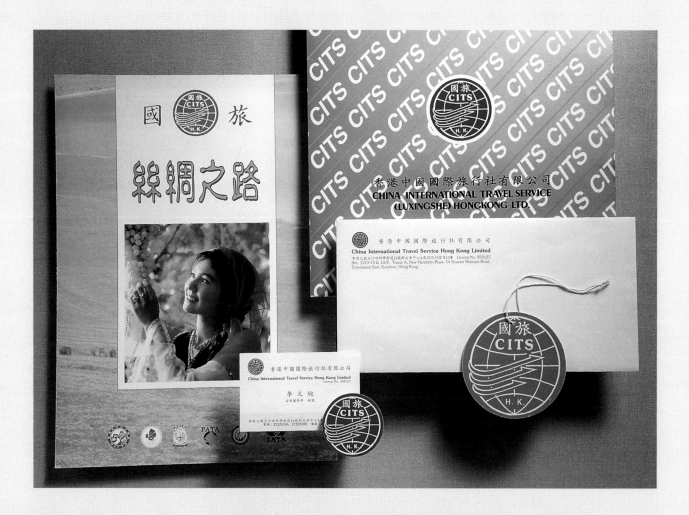

Before

The original mark for China International Travel Service, Hong Kong Limited was at least forty years old and did not stand out in the highly competitive tourism industry in Hong Kong.

Kan & Lau for China/Hong Kong Travel

Challenge: *A forty-year-old logo needs a completely new look that still relates to its original mark.*

"A WISE CHINESE MAN ONCE SAID, 'THE FORM is the entity and the entity is the form.' Adapting this hypothesis, the true inner self of a corporation becomes evident only if an appropriate image is established that creates a position in a prospect's mind," says Kan Tai-keung, principal with Freeman Lau of Kan & Lau Design Consultants, a leading design consultancy in Hong Kong.

This saying holds true for the original corporate identity of China International Travel Service (CITS), Hong Kong Limited. A subsidiary of the China National Tourism Administration, CITS offers China tours to people living in Hong Kong. Competition among tour companies in Hong Kong is fierce, and with a very dated, forty-year-old logo, CITS's image was not as strong and relevant as it could be, considering the market.

"The old identity was very conservative and old-fashioned," says Kan, whose firm undertook the CITS image redesign. The look was more corporate: It did not convey the fun and adventure of travel. To create a new identity, Kan began by considering the company's image, as well as another old Chinese saying.

"What is an image? We may get a hint from the saying, 'Our looks speak our minds.' Image is the look; it is a reflection of the true inner self," Kan says. "Corporate identities must show undeceivably the inner spirit of the corporation."

Because the original logo would still be used by the parent company, Kan felt that modernizing that mark might be the best direction. He began by sketching and re-sketching designs that used the globe element as a base. His early trials also picked up

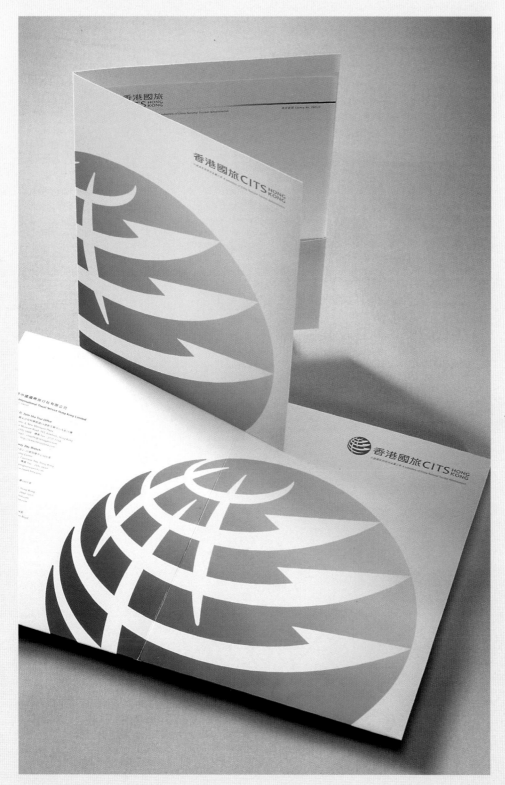

After

The new logo and identity is cleaner, fresher, and much more dynamic. The arrow elements on the globe suggest worldwide travel, and combined with a hint of latitudinal lines, they also form a free-form version of a Chinese character for *China*.

Because CITS's parent company would continue to use the original logo, the new mark needed a real familial relationship to the old. The globe shape provided a familiar base for Kan & Lau's sketch explorations. Arrows, birds, and the sun were added, abstracted, and simplified.

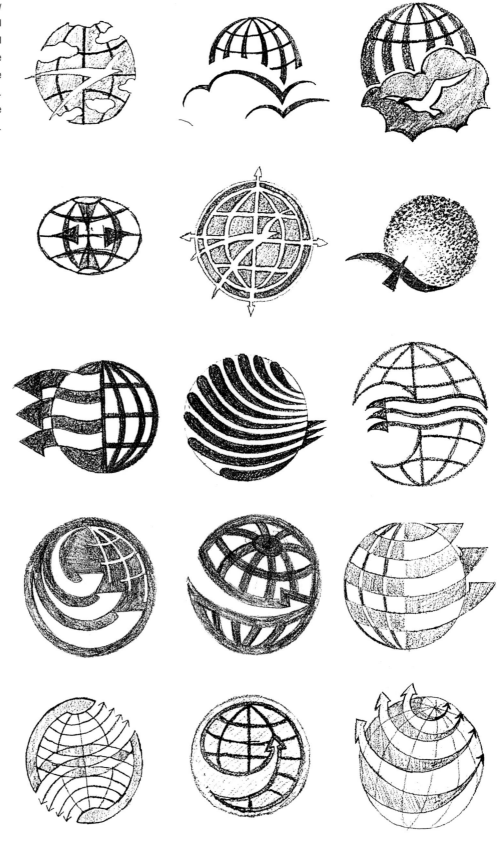

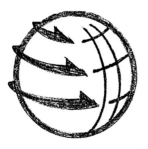

These sketches began to narrow
down the design direction.

on the longitudinal and latitudinal lines as well as
the arrows from the old mark, but as he worked,
these became more and more abstracted. He
explored bird and sun elements.

The arrow elements had a sense of motion and
excitement that Kan liked, so he continued work-
ing with these. Soon he could see that using three
arrows together with a suggestion of latitude lines
created a freeform Chinese character that repre-
sented the word *China*.

The three lines also had another level of
meaning.

"Arrows represent directions and are dynamic.
Also, in China, *three* means *many*. So the three
arrows mean much fun and job," Kan explains.

The mark was an excellent fit for the client's
needs in Hong Kong. The globe also represents
CITS's intention to develop business around the
world. Fresh, clear colors are used on bags, buses,
flags, tags, and other travel-related items. Kan says
that they represent the dynamism, variety, and joy
of travel.

The designer and his client both feel that the
new identity is successful because it expresses the
corporate philosophy in a visual image.

"Often, good logos become equal signs
between inside and out. What is expressed equals
what is intended," Kan says.

Now working on the computer, Kan &
Lau designers experimented with
positive and negative space and with
arrow positioning. Slight alterations
changed the logo from one- to three-
dimensional.

The addition of fresh, clear colors to designs using the finished mark adds a sense of excitement to the logo's sense of movement.

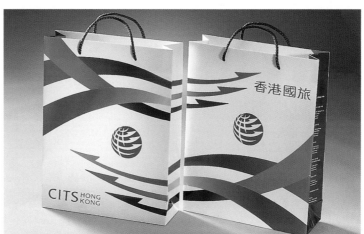

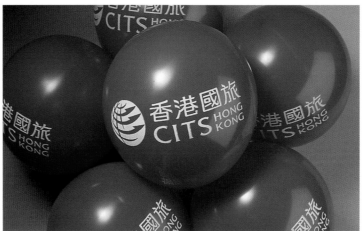

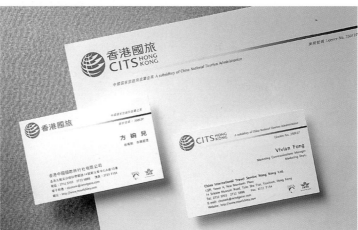

DESIGN FIRM:
Kan & Lau

CREATIVE DIRECTOR:
Kan Tai-keung

ART DIRECTORS:
Kan Tai-keung, Freeman Lau, Eddy Yu

DESIGNERS:
Eddy Yu, Veronica Cheung, Stephen Lau

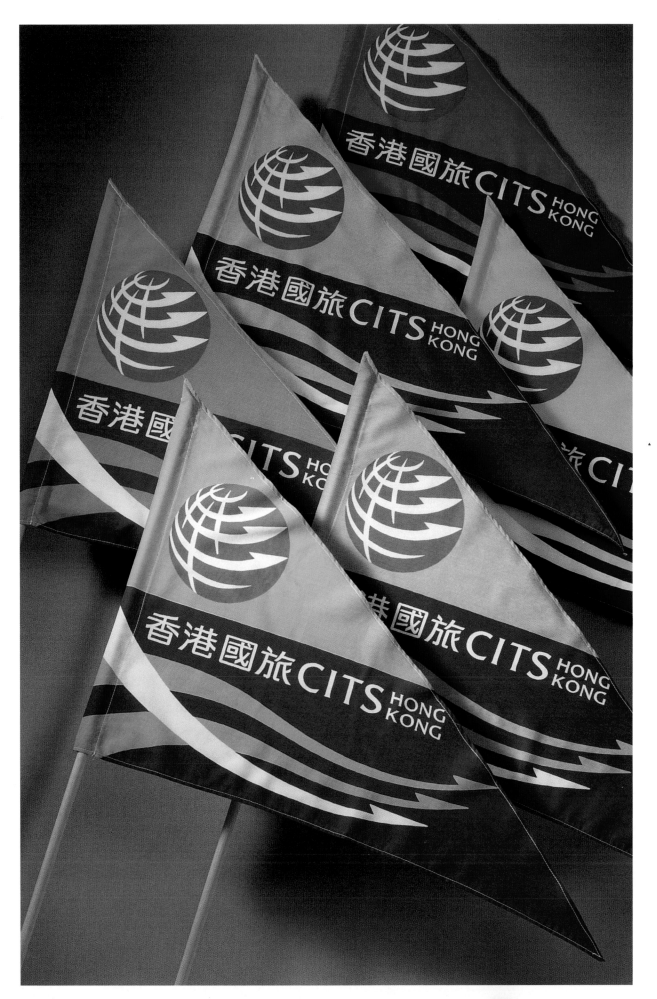

Before

Taco Bueno's identity and food didn't exude the kind of fun and health that teen and young adult patron's were craving. In addition, the identity was watered down by a wide range of different store exteriors and imitation Mexican decors.

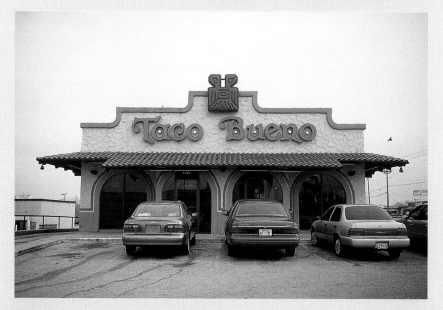

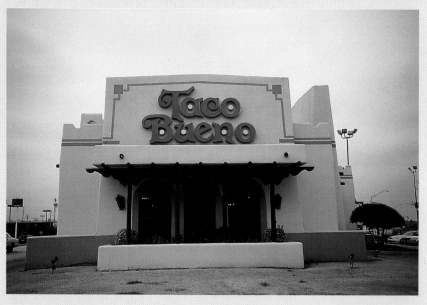

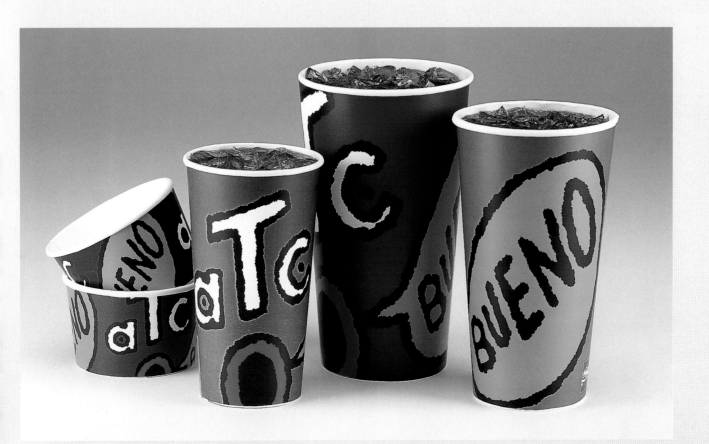

Pentagram for Taco Bueno

Challenge: *A regional restaurant chain looks to a major overhaul–from logo and menu offerings to buildings and interiors–in order to attract the fast-food consumer it desires.*

BUSINESS FOR TACO BUENO WAS ACTUALLY quite bueno when its new owners, Carl Karcher Enterprises, decided to completely update the chain of Mexican restaurants which were cobbled together from a series of acquisitions in the southwestern United States. Though Taco Bueno was conceived to be a fast-food chain, it wasn't pulling in the amount of business it wanted from its target audience, eighteen- to twenty-four-year-olds who are responsible for 75 percent of all Mexican fast-food purchases. While steady and dependable, Taco Bueno attracted an older crowd, which limited its potential for growth in a very competitive business.

Pentagram was hired to reverse this rather conservative image through an integrated program of branding identity and architecture. By creating an irreverent and playful attitude for Taco Bueno, Pentagram, working

with Mendelsohn/Zien Advertising, transformed the chain into a hip destination where this image-conscious age group could go to satisfy cravings for big portions of inexpensive, fast Mexican food.

"Taco Bueno's target audience is an age group that does not necessarily embrace rules for rules' sake. This program presented one of those rare opportunities to break most of the conventional rules in coining identities," says Pentagram principal Lowell Williams on his firm's ultimate solution. "We basically said, 'Here are some components and some colors, and virtually any combination of these elements is acceptable. Go do it. You can't mess up. Spontaneity and variety are not the enemy.'"

Taco Bueno's 110, or so, restaurants fell somewhere between full-service dining and fast food. Inauthentic Southwestern architec-

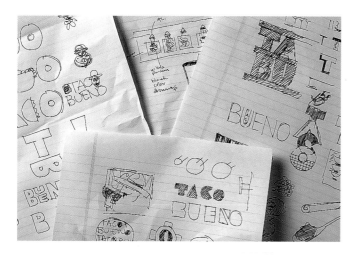

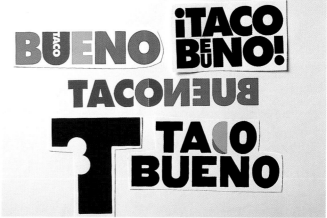

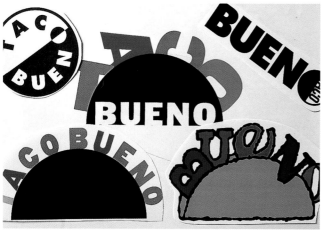

ture, outdated typography and logo, and a solid but uninspired menu were all working against a real opportunity for growth while the U.S. demand for Mexican food was going through the roof.

When Pentagram began working on the project, there were two givens: First, the Taco Bueno name would not change. Second, there had to be an architectural plan not only for building new stores with the new look, but for marrying the old buildings with the new style as well. Among existing buildings, profitable, high-volume stores would receive the most attention in remodeling.

After immersing itself in the fast-food business, Pentagram explored a series of identities, starting with a taco shell full of alphabet letters spelling out *Bueno* and progressing to the ultimate choice, a caricature face formed from the letters in the word *taco*. The face expressed through a dialogue bubble—another cartoon device—the word

Bueno. (Part of the chain's and the design firm's thinking was that the *Taco* half of the name would eventually go away, leaving a well-established and far more flexible and unique *Bueno* identity.)

The architectural solution was constrained by having to give various buildings a singular, new look. Pentagram's choice from the start was to wrap the existing buildings, much in the same way that tacos and burritos are wrapped. In designing the wrapper, the designers looked for something that other chains did not do. This led to a simple, crisp, and colorful treatment which was much more distinctive and fresh than that offered by the competition.

The tilted-box wrapper drew upon the modern Mexican Architectural style of Luis Barragan, renowned for his use of sheer walls and flat planes adorned only by vibrant colors. The shape presented a number of design opportunities: The wrapper allowed light to

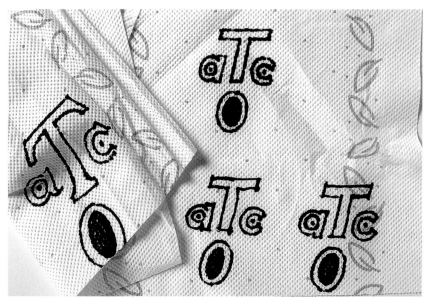

The a-ha moment came when it became clear that a face could be formed from the letters in the word *taco.* Principal Lowell Williams was trying to draw the word *bueno* inside the mouth. But when Leslie Pirtle, wife of Williams' partner Woody Pirtle, saw the face, she suggested that the face should be saying "bueno." The addition of the cartoon dialog bubble brought the character to life.

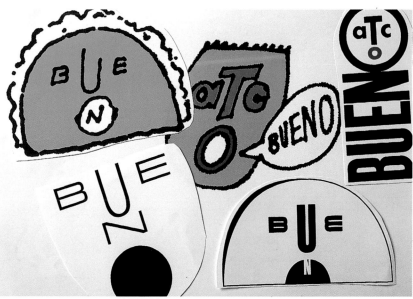

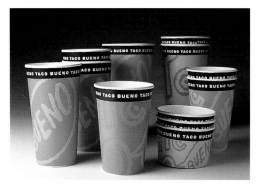
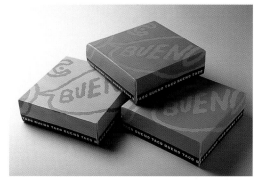

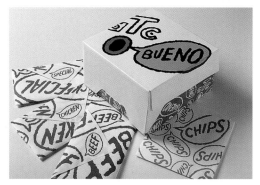
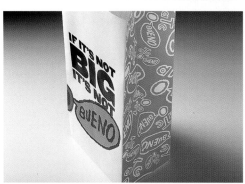

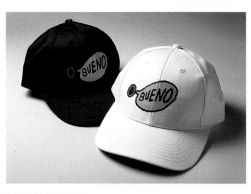

These comps show how colors balance cool and hot in a playful but sophisticated way. The symbols and colors can be successfully mixed together in almost any combination. Pentagram created this system so that Taco Bueno would have the flexibility it needed to create everything from small plastic cups to exterior signage.

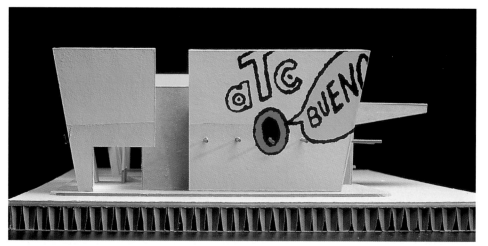

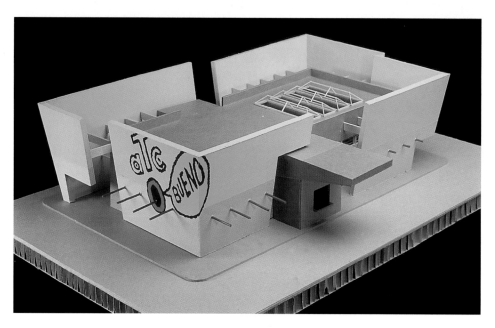

These architectural models show how the wrapper concept works. New buildings can be constructed in this style, of course, but existing stores can be wrapped in the new look as well.

filter in between itself and the original façade, which alters the look of the restaurant depending on the time of day. It also allowed the designers to specify large expanses of glass in the inner walls, which were protected from heat and glare by the wrapper. Plus, the flat walls provided backgrounds for big, bold graphics, creating multisided billboards that gave Taco Bueno a stronger street presence, something it never had before.

The roll-out of the new identity has been very successful: All new packaging now is in place, TV spots using the new identity are running, and three new stores have already been opened. By January 2000, fifteen new stores will open and thirty existing restaurants will be remodeled.

"The basic proposition for the program is that everything has the same look, but not look the same," says Williams.

DESIGN FIRM:
Pentagram

DESIGNER:
Lowell Williams

ARCHITECT:
Jim Biber

Before

For many years, Eagle Star's identity centered on the image of an aloof, impassive, even threatening eagle. The star element in the name was there, but it was decidedly secondary.

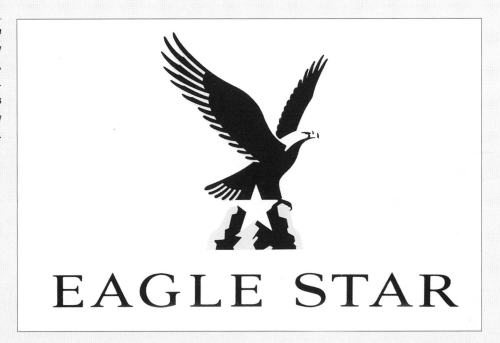

Despite its less-than-positive connotations, the eagle image carried too much power to be abandoned. So designers looked for ways to combine the eagle and the star in a single image.

The simple action of folding over a point on the star quickly became the favored approach.

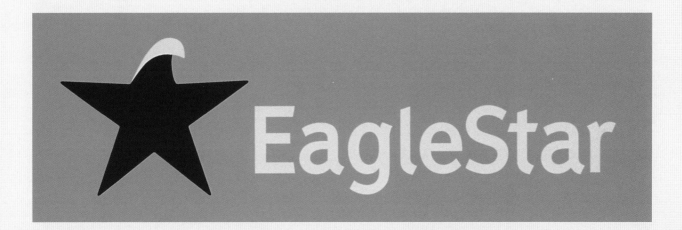

After

The new identity is fresher and friendlier in color, image, and mood. It better represents the company's new dedication to being more accessible and flexible.

The Partners for Eagle Star Insurance

Challenge: An insurance company with a rock-solid reputation needs to soften its identity when customers begin to demand a friendlier interface.

EAGLE STAR INSURANCE IS ONE OF MANY British financial and insurance businesses founded in the 1800s. The company has been around so long that it is a countrywide institution, a symbol of solidity and safety.

Trouble was while it remained rock-solid, their customers had changed drastically. People no longer wanted an impassive institution: They wanted service with a human face, service that responded to customers and did so more quickly and with more imagination. Eagle Star risked losing some of its customer base unless it changed its image drastically.

Eagle Star turned to The Partners for advice. Principal James Beveridge explained his client's predicament: "The original collateral and symbol were very conservative, cold, and technical. It all said, 'This is what *we* provide; this is what *we* offer.' They needed to change their positioning, and they also needed to stand out."

The Partners' designers began by looking at the core element of the old identity, the eagle symbol. What they found was a creature that customers saw as aloof, even a little threatening. But because it was such a logical visual connection to the company's name, to abandon it seemed foolish.

But a secondary element appeared in the mark—a star—though consumers did not remember this portion. So thoughts turned to what else could be done with the star, perhaps combined with the eagle without compounding the perception of inaccessibility.

Visual explorations abandoned realistic imagery and centered instead on more positive symbolism. Beveridge calls the final star-turned-eagle symbol "one of those lovely sparks of creativity." The new symbol adds a bit of humor to the identity, and the friendly eagle was simultaneously made more memorable.

The original logo was a chilly dark blue; designers felt warmer coloration was crucial to the new identity. They selected a fresh,

DESIGN FIRM:
The Partners

CREATIVE PARTNER:
David Stuart

DESIGN PARTNER:
James Beveridge

STRATEGY PARTNER:
Gareth Williams

SENIOR DESIGNERS:
Annabel Clements, Steve Edwards

DESIGNER:
Steve Edwards

PROJECT DIRECTOR:
Louisa Cameron

PROJECT MANAGER:
Julie Anderson

TYPOGRAPHER:
Mike Pratley

A brighter palette, based on a bright royal blue and fresh lime green, also warms the new identity's feel.

Designers also rethought the number and quality of words. By using fewer words and friendlier language—with a healthy sprinkling of *you* and *your*—the entire subject of insurance seems much less intimidating and much more helpful.

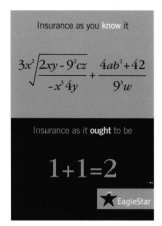

vibrant green and a brighter blue, a very different direction for the client. "We showed [the client] lots of different color options to make the point. Once they understood that there was a method behind our color choices, they agreed," Beveridge says.

Fewer words and more accessible language across the board characterized another major part of the new ID. "The writing couldn't be for underwriters," Beveridge explains. "They needed to begin talking about their technical products in a no-nonsense way, with a whole lot less copy that was more interesting and relevant."

In pilot tests, the new identity has been very well received. Beveridge says it is also exciting to see how the internal culture at Eagle Star is changing as a result of the new look: "They are seeing themselves in a different way and are finding how they can deal with customers in new ways. Eagle Star had the courage of its convictions. It wanted an icon that its people would be proud of. It's like a banner that they can stand behind."

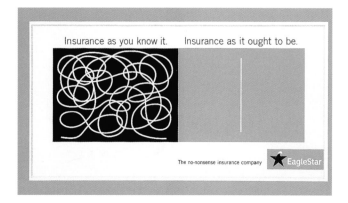

A series of witty ads used simple elements to graphically represent Eagle Star's new attitude.

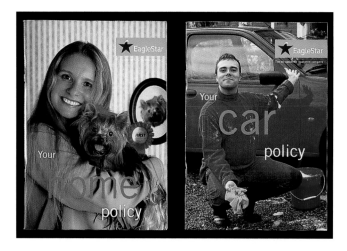

Photography of real people in real situations, in contexts that illustrate their pride in accomplishment, also helped bring the message home.

The new, friendlier Eagle Star mark can also be very bold and dramatic in environmental applications.

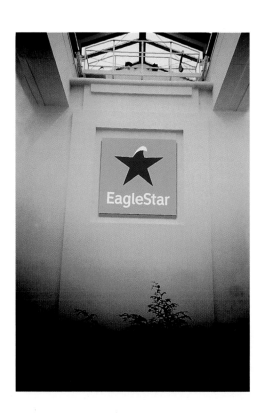

MANAGING CHANGE

—JILLY SIMONS OF CONCRETE, CHICAGO, ON MAN-
AGING CHANGE, IN HER OWN OFFICE AS WELL AS IN
THAT OF HER CLIENTS—

"After you create a new identity for a client, you
try to control it as much as possible. Style guides are
the obvious way. You don't want to restrict clients'
creativity, but you want to give them a good skeleton
to hold onto, something that won't interfere but that
they can build around.

"We just received a brochure from a client who
has used the colors and type and such that we set up
for them, but they have proudly reinterpreted the
material to meet their needs. They have the author-
ship. That's good. Some less creative clients may
want us to be their design police. One client will call
us every time they implement a new piece, even to
report how their business card is doing. This is
thrilling for us.

"But at some point, we have to step away. You
have to let the chick out of the nest. We learn to use
diplomacy when we see what they are doing and
hope we can make recommendations about how to
improve it. But I know I'm not designing in a per-
fect world. We get so close to these projects. It has
taken me a lot of years to learn to step away. But I
still go home and beat myself up about it when what
we design isn't used as we intended for the client."

FRANKEL&COMPANY

Before

Frankel's old mark and identity
wasn't a good match for the profile
of the current company: It didn't
indicate what Frankel did, and it
looked dated. But as much as
Frankel's in-house designers wanted
to rework it, they were too busy with
client projects to dedicate the amount
of time that it would require.

FRANKEL.

BRAND FRANKEL.
MARKETING

After

Completely overhauled by Concrete, Chicago, the new Frankel identity has strength and personality, and in the signature, it says what the company does. "It also gives Frankel something to hang its hat on," says Concrete's principal Jilly Simons, "a way to control their identity internally and externally."

Concrete for Frankel & Company

Challenge: A company full of talented designers and art directors needs to avoid an identity of multiple personalities.

FRANKEL & COMPANY, A WELL-ESTABLISHED brand marketing agency in Chicago, was growing substantially. New offices were opening and the firm's employee roster was doubling. Launched in the 1950s with a single, though very promising, client—McDonald's—today's company, now known as Frankel, Brand Marketing, creates brand identities for corporate world leaders.

To do this type of high-level work, Frankel employs a large and talented roster of art directors and designers. The internal design staff realized that the company had grown so much that its old identity no longer matched the group. But because they were immersed in client work, they didn't have time to complete an overhaul. Instead, they introduced tweaks here and there.

"They do have a lot of designers and art directors, but they are so busy on so many client projects," explains Jilly Simons, principal of Concrete, Chicago, the firm that was

brought in to give Frankel a new look. "These people were dying to have something that was much more identifiable. Because of this, there was a tendency for everything going out to look different. Everybody added their own personal touch."

A quick visual audit of Frankel's old materials proved her point: The Frankel identity was all over the place. In addition, the core logotype had a look that didn't say anything about the current company's dynamic nature.

To rein in all of the creative directions and better define Frankel's core values, Simons and her staff made simple lists of words and phrases that described their client, gathered in previous meetings. These were offered as suggestions, but Frankel agreed with most of their assessments. From these lists, a single statement was developed to drive the design: "Frankel is about strong, friendly people doing smart business.

DESIGN FIRM:
Concrete

DESIGNERS:
Jilly Simons, Kelly Simpson

CLIENT LIAISON:
Susan Boyd

PRINTER:
Rider Dickerson

frankel is:
(an informal combination of your comments and our observations)

growing
excitement

changing
flexible

corporate
informal

professional
real

strategic
creative/innovative
problem-solving

targeted

big shoulders
unpretentious

solid

deep

a partner

a catalyst

resourceful

responsive

smart

entrepreneurial

hierarchical

competitive

straightforward
honest (midwest)

forging
a tank

diverse

moderate
(but not traditional)

masculine

a group of people
friendly/casual/warm

frankel isn't:
(an informal combination of your comments and our observations)

leading edge
out-there

young

trendy/hip

austere
unfriendly

soft

feminine

intimate/delicate

international
(not yet!)

a "boutique" agency

design-y

design forward

high tech
(not yet!)

the new frankel image should reflect:
(an informal combination of your comments and our observations)

power
growth, global outlook

distinction

value

knowledge

experience

equity
history

solidity

relevancy

creativity
(vague?)

self-image
honesty

personality
(who's?)

heart
(vague?)

frankel provides powerful, attentive partnering. frankel provides astute and smart strategies. frankel is a growth company. frankel is about process. frankel is high energy.

in summation: frankel is about strong, friendly people doing **smart business**. there's excitement in the air, the people are responsive.
frankel is primarily about good business.

F|FRANKEL

FRANKEL.

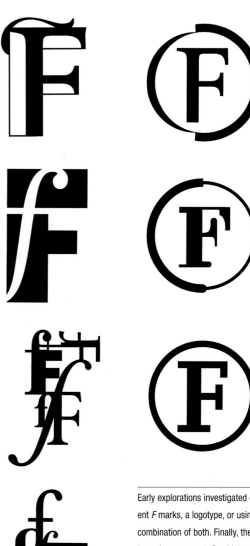

There's excitement in the air. The people are responsive. Frankel is primarily about good business."

With the direction of these lists and the mission statement, Concrete could begin working. Right away, "& Company" was dropped from the name. Frankel initially wanted a mark or icon, so Concrete explored various directions. The *F* mark became a dominant focus. It could provide the identifiable, single element that the client wanted; combined with a circle element, the mark could suggest globalization. Different color palettes were envisioned for customization. "We didn't want the mark to be dead or stagnant," Simons says.

But in the end, everyone agreed that Frankel's strength was in its name; the single *F* mark simply couldn't communicate that. But customization could: With so many different kinds of clients and layers of business, a changeable, yet constant identity was the perfect fit.

To compensate for eliminating the mark, Concrete designers developed a pattern system to keep everything fresh and lively, including a corporate plaid, a crazy plaid, small checks, and large checks. The corporate colors—a slightly grayed orange and an eggplant purple—are accented with cream, cinnabar, dark gray, and black. Typefaces are kept simple but strong: Adobe Frutiger Condensed and FF Scala.

The color palette and the pattern palette give Frankel plenty of options. "We wanted to give them enough of a palette that they could use it many ways," says Simons. "The patterns are controlled, but it gives them a living ID that they can personalize."

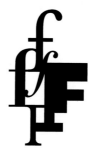

Early explorations investigated different *F* marks, a logotype, or using a combination of both. Finally, the logotype alone won out. Combining script or italic letters with solid sans serifs expressed Frankel's many capabilities; circles denote its growth and globalization.

opposite

These printouts were part of Concrete's initial presentation to Frankel. They reflected the designers' impression of the client based on early discussions. Though they were completely open to debate, Frankel agreed with most of these assessments. The final statement was developed to drive the entire identity design.

FRANKEL.

The second round of studies was narrowed down to a logotype and a mark. They focused on the logotype and placed secondary emphasis on the mark, as shown on the stationery. Other personality treatments also begin to emerge, such as the rounded corner on the business card. Positioned where most people would hold the card, it suggests a thumbprint: It provides a tactile, interactive quality.

MARKETING AND PROMOTION

111 EAST WACKER DRIVE
CHICAGO IL 60601 4884
P 312 938 1900
F 312 938 1901

CHICAGO DETROIT
SOUTHERN CALIFORNIA
SAN FRANCISCO

FRANKEL.

SUSAN J. BOYD
SENIOR VICE PRESIDENT
EXECUTIVE DIRECTOR

MARKETING AND PROMOTION

111 EAST WACKER DRIVE
CHICAGO IL 60601 4884
P 312 938 2273
F 312 819 8799
E SUSAN@AOL.COM

FRANKEL.

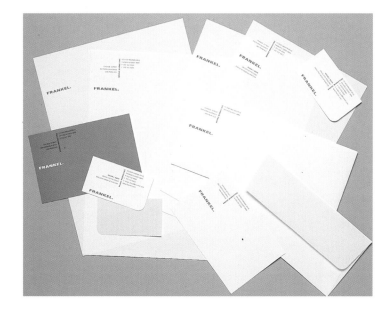

The identity system as played out on Frankel's business papers is strong and creatively confident. The period used behind the logotype makes the name a real statement, reinforcing what Chicagoans call "big shoulders."

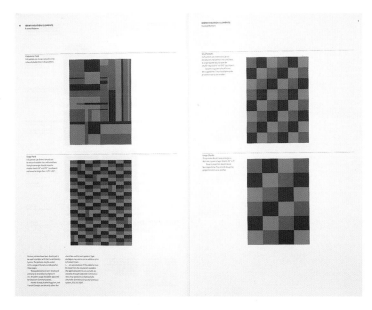

Other print pieces manifest the identity boldly—through patterns that Frankel designers can apply in different ways. The patterns are all different but familial.

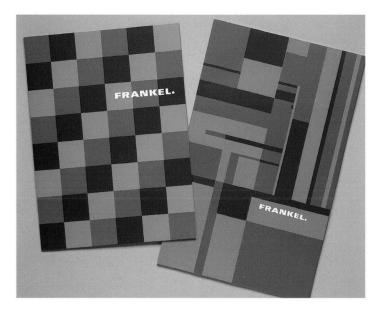

The style guide and press folder show two different uses for the corporate patterning.

Pattee Design for Kirke Van Orsdel

Challenge: *A company in the midst of a buyout needs a transitional identity that respects the original organization as it moves employees and customers toward the new corporate culture.*

Kirke Van Orsdel, Inc. (KVI) is a leading outsource of data administration for insurance and other benefit programs for corporations. Often, the firm is invisible to its client's clients: For instance, KVI may build and maintain a Web site for a client, but users only see the client's identity when they visit the site.

KVI's identity was anything but invisible to its employees, especially when the company was bought out by its sole competitor of many years. KVI was given two more years to operate under its current name; then the transition to a new, combined identity would be launched. The company's name had a lot of equity, and throwing out everything at the end of the two years was simply too scary, especially for KVI employees already nervous about their futures. A transitional identity seemed wise, one that said something about the new and old organizations.

Pattee Design was called in to handle the sensitive job. "We wanted to evolve their

identity to include the Seabury & Smith name," principal Steve Pattee says, "and use that combined message for the internal audience and KVI clients to show that everything was still OK, but now they are part of a bigger organization."

Updating the mark was one part of the new identity. But the awkward shape of the original logo made any face-lift difficult. Pattee first worked to turn the mark into what he calls a more "comfortable" symbol. Tilting it forward or back lessened its jaggy nature, as did breaking it into lines or other shapes. His ultimate solution placed the now sans serif mark inside of a simpler shape, a square. "A division of Seabury & Smith, Inc." was added below the letterspaced company name.

Subtle color modifications also provided a respectable nod to the new parent company. The imprinted square is run in silver and blue, Seabury & Smith's colors, while the cream color of KVI's original stationery

DESIGN FIRM:
Pattee Design

Print

ART DIRECTOR:
Steve Pattee

DESIGNERS:
Steve Pattee, Trenton Burd, Kelly Stiles

COPYWRITER:
Monica Green

PHOTOGRAPHER:
Scott Sinklier

PRINTER:
Holm Graphic

Web

ART DIRECTOR:
Steve Pattee

DESIGNERS:
Kelly Stiles, Trenton Burd

COPYWRITER:
Monica Green

PROGRAMMING:
Synectics International

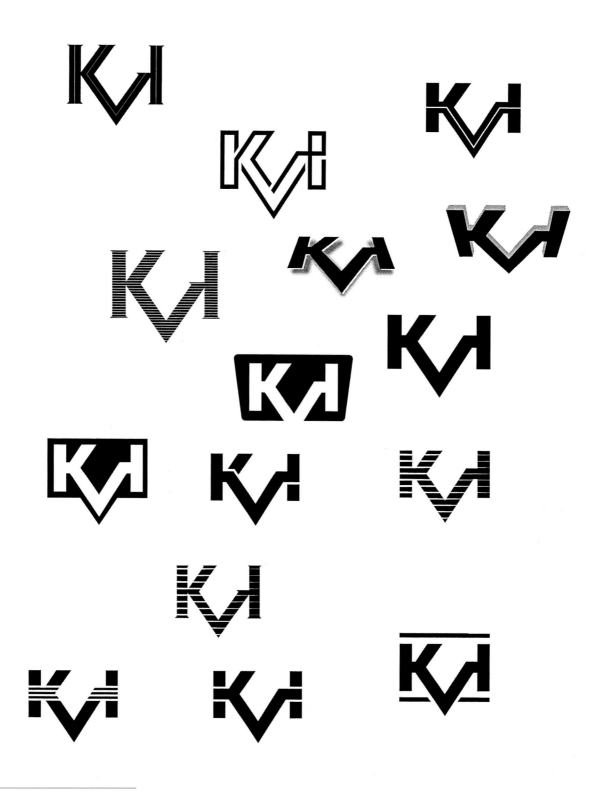

To minimize the awkward shape of the KVI logo—which was so distinct that it could not easily be married with anything from the new parent company—Pattee Design tried to break up the mark, increasing its perspective and therefore flattening it, as well as transforming the *I* into an exclamation point.

KVI's original collateral had a high-design look. But it was somewhat sterile considering the company's business: helping people with their benefits.

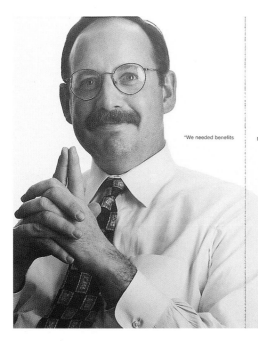

"We needed benefits

program management that could bring product breadth and depth to our members."

Starting with its title, "better solutions, together," KVI's redesigned capabilities brochure is all about people working together: KVI working with its clients and with its new parent company.

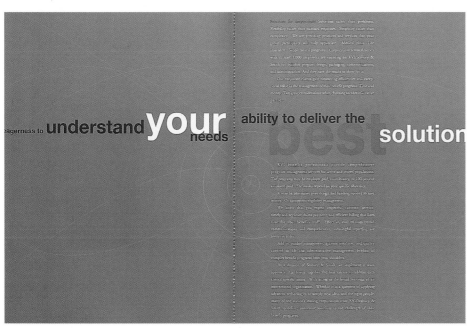

eagerness to **understand your** needs **ability to deliver the** best **solution**

Another interesting exercise in making connections between people are these unique diagrams, also from KVI's capabilities brochure. The full-spread diagrams demonstrate graphically how KVI/Seabury & Smith help their clients.

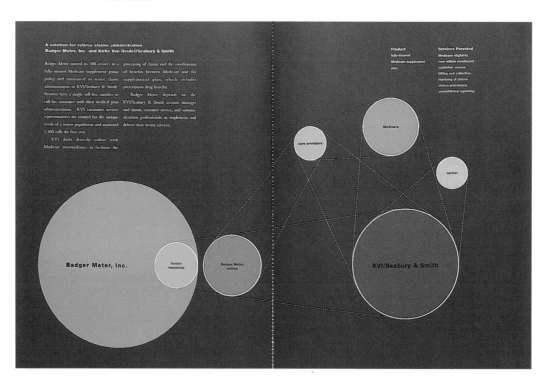

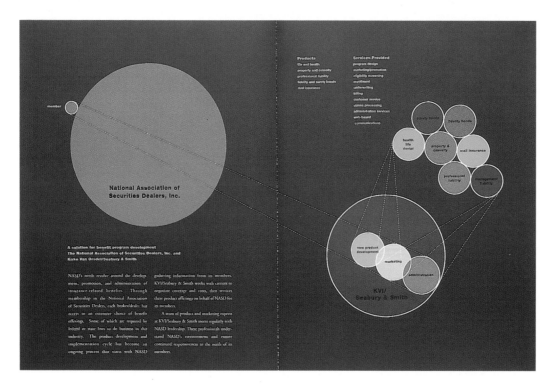

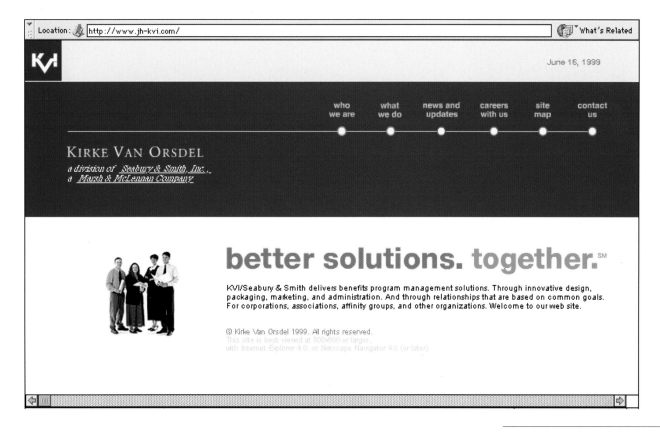

June 16, 1999

who
we are

what
we do

news and
updates

careers
with us

site
map

contact
us

KIRKE VAN ORSDEL

*a division of Seabury & Smith, Inc.,
a Marsh & McLennan Company*

better solutions. together.℠

KVI/Seabury & Smith delivers benefits program management solutions. Through innovative design, packaging, marketing, and administration. And through relationships that are based on common goals. For corporations, associations, affinity groups, and other organizations. Welcome to our web site.

KVI's Web site continues with the person-to-person theme. The site is simple in design and straightforward in content.

provides a familiar note for employees and customers.

Moving from its client's mark and business papers, Pattee moved on to collateral pieces and the company's Web site. KVI's old materials contained plenty of photos of buildings and stock-photo people, images that did not very meaningfully relate to customers. The redesigned materials have a completely different identity; they focus on person-to-person communications: Friendly KVI employees are portrayed with their customers and success stories. The effect is friendly and fresh.

"This allowed KVI to talk about the great relationships they have with the customer," Pattee says. The testimonial approach actually helped with some interesting education internally, he adds: By showing all manner of different people working together, the material helped to foster understand-

ing between KVI and Seabury & Smith in what could be a difficult time.

As much as he would have liked to start over with a completely new mark and identity for KVI, that drastic a solution would not have helped to solve the client's problems. "Internally, they felt close to the old logo, and internally and externally, it had equity. It's like the McDonald's arches: Those aren't necessarily brilliant graphics, but there's no one in the world that doesn't know what they are."

It's important, Pattee says, to be accountable to the client's goals and not get too heady with the design. "You have to understand the client's cultural idiosyncracies. It's all criteria-driven, and the most important criterion is success. To come off with something that doesn't respond to their criteria is not a success."

DESIGN FIRM:
Pinkhaus

CREATIVE DIRECTOR, CORPORATE IDENTITY:
Kristen Johnson

ART DIRECTORS:
Mark Cantor, Raelene Mercer, Claudia Kis

COCREATIVE DIRECTOR, WRITER:
Frank Cunningham

STYLE GUIDE WRITER:
Cheryl Kaplan

ACCOUNT MANAGER:
Teri Campbell-Balter

CREATIVE DIRECTOR, BRANDING:
Christopher Vice

ART DIRECTORS:
Raelene Mercer, Todd Houser,
Angie Smith, John Westmark

COCREATIVE DIRECTOR, WRITER:
Frank Cunningham

ACCOUNT MANAGER:
Teri Campbell-Balter

Pinkhaus/Designory for Sterling Associates

Challenge: A leading provider of business-to-business electronic commerce solutions requires a strong brand identity to unify its many offices and divisions.

STERLING COMMERCE HAS BUILT ITS business by delivering electronic commerce solutions for more than twenty-five years, working with over 42,000 customers worldwide including all but four of the *Fortune 500* companies and ninety-nine of the one hundred largest U.S. banks. The company was formed by spinning off several existing companies that had been bought by Sterling Software. Each brought with it a product portfolio and graphic identity. The newly merged companies continued to operate autonomously, retaining their own identities and marketing materials. A wide variety of looks and messages resulted.

But a company the size of Sterling Commerce requires a single brand identity, so the company approached Pinkhaus to develop a corporate identity system that would unify the company under a "one brand, one voice" umbrella. However, with thirty-six offices and more than forty distributors worldwide, the company needed a design system that was flexible, one that would allow the individual groups to fulfill their independent needs as well as their own creative preferences. A successful identity would enable them all to produce collateral and marketing materials with a consistent design theme and a strong, unified identity.

CONNECT · DIRECT · OVERVIEW

HIGH-SPEED,
HIGH-PERFORMANCE
SOLUTION FOR ENTERPRISE DATA EXCHANGE

In today's highly distributed computing
environments, moving data point-to-point is not
enough. Organizations need powerful enterprise data
exchange solutions that can intelligently link,
route, and manage the flow of information
To meet these

CONNECT · PRODUCT · OVERVIEW

Today, financial institutions, universities, government agencies
and commercial enterprises are eager to build efficiencies into
their businesses. Expecting to create competitive advantage,
increase service and enhance productivity, they are streamlin-
ing operations and reducing manual processes. On a global
scale, the power of electronic commerce is enabling and
supporting these changes.

Electronic commerce covers any form of business transaction
that is conducted electronically. Such transactions occur
within and between companies and their business partners.
Electronic commerce is not just about buying and selling over
the Internet. It's about using technology to transform every
aspect of the way we do business today. Electronic commerce
includes not only the "paperless" electronic trading of physical
goods and services but the facilitation of contacts between
traders, the provision of market intelligence,
promotion/advertising of products and services, pre- and po
sales support, electronic procurement and support fo
business. Electronic commerce effectively links b
processes and delivers organizations secur
managing the exchange of business
corporate enterprise as well a
customers and trading p

WEB SUITE

GENTRAN

WEB COMMERCE

STERLING COMMERCE

▲ AUTOMATE BUSINESS PROCESSES
▲ GAIN MEASURABLE RESULTS
▲ REALIZE UNPARALLELED VERSATILITY
▲ LEVERAGE FULLY INTEGRATED AND
SUPPORTED SOLUTIONS

After

After Pinkhaus evaluated the needs of
the groups that made up Sterling
Commerce, it was able to create an
umbrella identity that was flexible
enough to let the individual groups
insert their own creativity, yet it
maintained a consistent look for
Sterling Commerce.

The designers provided Sterling with a preset grid for future layouts, but they also furnished a number of different templates for specific pieces, a few of which are shown here.

The redesign began with a three-month audit of every piece of collateral material produced by the company. The result: A four-foot-high, forty-three-foot-long chart illustrating the marketing communications process of the company as well as each piece of collateral and how it was used. From the chart, Pinkhaus evaluated the diverse selling processes of each group, then devised a strategy to eliminate redundancies and extraneous marketing materials.

With the audit completed, the redesign could begin. The corporate logo was the only design element that had to be retained. However, a bounding box was added to begin to establish an anchor for the logo within the new design system. But the designers created a secondary application of the corporate mark that could be used on collateral materials. This variation of the original logo allows the mark to be shown apart from logotype; it is also used when a more reserved elegance is required.

The next step was to produce a portfolio of templates for each of the collateral and marketing materials to be used by each group. "We needed a system with strong direction, but it also required a lot of flexibility," says creative director for identity Kristen Johnson. "We began with an essential grid structure and developed a series of symbols and a library of imagery from which design could be constructed. We also chose to develop a palette of color, as opposed to the traditional two or three spot colors that most corporations rely on."

Christopher Vice, creative director for branding, agrees. "We created a controlled environment, but one with enough flexibility to allow creativity and exploration."

Sterling Commerce has been working with the new system for more than a year. Each of the independent marketing groups report that it does offer flexibility and freedom while providing the guidelines they need to stay within the parameters of the identity. In fact, the framework Pinkhaus provided actually saves in design time.

Stock visual libraries provide Sterling's various divisions with hundreds of design options. These abstract symbols were developed from abstract concepts that described Sterling: global, creating, connection, unifying, structure, pathways, and so on. A stock photo library that keyed on these same concepts was also assembled.

This symposium invitation shows a number of components from the identity working together: color, grid, type, and concept visuals. Despite the large numbers of components, the identity still is unified.

These spreads from various Sterling publications display a playful attitude toward type that the old identity system couldn't accommodate.

Before

Artville's old logotype was colorful and full of life, but it had the personality of an "adolescent teen," not of a "sophisticated adult with style," which the company's President/CEO Miles Gerstein wanted.

Planet Design for Artville

Challenge: A company that grows up in a hurry must develop a mature, more elegant identity that bespeaks its new status.

DESIGN FIRM:
Planet Design

CREATIVE DIRECTORS:
Kevin Wade (Planet), Cynde Quinn (Artville)

ART DIRECTION, DESIGN:
Martha Graettinger, Kevin Wade

DESIGNER:
Kelly Hargraves

WEB SITE DEVELOPMENT:
Ben Hirby (Planet), Jason Owens (Artville),
Berbee Information Networks

COPYWRITER:
Seth Gordon

ACCOUNT MANAGEMENT:
Suz Brewer

NOT UNTIL THE IMAGE BANK PURCHASED the stock art and photo company Artville did an identity redesign became imperative. With a greatly expanded product line, Artville needed a more mature look that announced in a substantial way the company's new status as a major supplier of everything from spot art to art photography. With a target audience made up largely of designers, Artville also needed to raise the aesthetic bar.

Artville's in-house creative staff, led by Cynde Quinn, had actually begun to explore new logotypes, among them a simple rectangle enclosing the name. When Planet Design entered the picture, the design firm inherited that work.

"They had created a chunky, square version with Futura. It was a big move from their original colorful, animated mark. But we thought we should look at it again," says principal Kevin Wade, noting that the mark didn't convey the elegance and maturity it

should. "The Futura just felt old."

However, Planet designers could sense the type of simplicity the client sought. They began experimenting with the typeface Nobel and the bounding frame. They tried different letterspacing and kerning, and they rounded off corners of the box. They ended up with a mark that acts almost like a cattle brand that can be stamped onto nearly anything.

Artville's two-sided business cards show off the brand's flexibility: One side of the card is imprinted with a full bleed of one of forty different tightly cropped Artville images, the company's mark stamped at center on top of the art. The prominence of the identity nevertheless allows the product to shine through.

The client's catalogs also needed to be revamped. Past editions were saturated with hundreds of little blocks of images plus plenty of copy and bullets. New issues, much

IMAGES

After

Planet Design's solution did indeed
have the elegance of a more mature
identity, but not so stylishly that it
distracts from the client's products.

ARTVILLE ®

STOCKIMAGES

simpler and targeting an audience of young
designers, introduce more white space and
small blocks of thought bombs. "If they
wanted to do something different," Wade
says, "they had to move away somewhat from
the standard catalog approach. We wanted to
create an identity through the catalog form.
Less could be more, and simple is definitely
better here. Text is kept minimal. We've
created a canvas or an atmosphere in which
the art can appear."

In future catalogs and on the client's Web
site, Wade wants to create the sense of
Artville as a destination, as its name suggests:
"There's a place in your mind that you visit
for ideas. Artville is where you can go to
embody the ideas."

Artville's in-house creative staff already had begun to play with a new brand mark, using Futura contained in a rectangular box. Planet designers could sense the simplicity that Artville wanted but believed the mark could be even more minimal. They substituted the typeface Nobel, which they felt had just the right amount of personality, experimented with letterspacing and type sizes, and rounded off the box until they hit upon the appropriate solution.

ARTVILLE
STOCKIMAGES

ARTVILLE

ARTVILLE

ARTVILLE

ARTVILLE

ARTVILLE

ARTVILLE ®

ARTVILLE ®
STOCK**IMAGES**

ARTVILLE ®

STOCK**IMAGES**

2310 DARWIN ROAD, MADISON, WI 53704
PHONE 608.243.5956 FAX 608.243.1174
WWW.ARTVILLE.COM

MILES GERSTEIN PRESIDENT & CEO

Artville's two-sided business card was the first piece of the identity program to feature the new personality. The brand is prominent, but the product is showcased at the same time.

Artville's new catalog covers and interiors will follow the less-is-more approach. The previous design was filled to the brim with postage-stamp-sized images and plenty of copy. The new design is based on a loose grid system with thin rules to divide space. Small red arrows indicate important information, and white space and large bleed images offer relief from info-heavy pages.

ROYALTY-FREE, RAT-RACE FREE ILLUSTRATION AND PHOTOGRAPHY.

ARTVILLE

SUMMER 1999

ARTVILLE

PHOTO OBJECTS/BACKGROUNDS

ARTVILLE

FREE LUNCH

AND 4100 OTHER FREE IMAGES!

Fat FREE. Sodium FREE. Resource Book FREE. The Artville Resource Book 2 features some of our most recent and popular titles. Each copy also includes a free Resource CD for comping.

Just ask our representative to add a Resource Book to your next Artville order, and we will send you a free copy for a mere $3.00 extra in shipping.

If you aren't placing an order now, you can still receive a free Resource Book. All you pay is a $7.95 UPS Ground shipping charge.

ILLUSTRATION

ARTVILLE

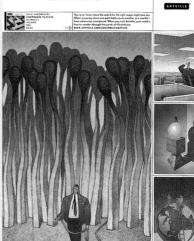

The company's Web site was also completely redesigned to make it consistent with the repositioning. Designers approached the site's aesthetics and functions with the same goals of simplification, speed, and user-friendliness. Again, generous white space helps the art and photos pop off the screen.

Before

Each discipline within HNTB—planning, architecture, and engineering—was in charge of promoting itself, so the company promoted itself with a wide range of very different collateral materials. There was no commonality of image.

After

Rigsby Design tied everything together yet maintained the flexibility of HNTB's old system in a bold, bright system that immediately identified itself to the recipient. No real logo appears. Instead, nameplates identify and customize each piece.

HNTB's old system was easy to customize for particular clients. The new identity preserves that through binders with accordion-folded spines held shut with elastic cord. Anything from a single sheet to a several-inch-high stack can be accommodated. Plus, the neoprene-covered yellow covers (the same rubber used to make scuba gear) offered a durable, protective cover for proposals that must survive for many months, maybe at grimy construction sites.

Rigsby Design for HNTB Architecture

Challenge: *A company has so many strong capabilities that it begins to lack a unified identity.*

HNTB ARCHITECTURE, ONE OF THE LARGEST AND most noteworthy architectural firms in the United States, is known for its design of airports, sports facilities, hotels, universities, countless corporate facilities, and much more. HNTB was recognized for so many different kinds of work that its identity had become somewhat splintered, both internally and externally.

This identity crisis was compounded by the firm's collateral materials. Because each discipline in the company—planning, architecture, and engineering—controlled promoting itself, no commonality of image emerged. Some architects saw HNTB as a high-design firm, while others wanted its image to focus more on a connection with HNTB's engineering services.

The result: the public could not perceive what HNTB was all about. Most people didn't know what the company did, or they thought it did just one thing (design airports, for example). From a business standpoint, partner and client companies weren't sure what they could expect from the firm. Internally, key values were fuzzy.

The positive in this large but uncoordinated wealth of materials was that HNTB continuously created highly customized packages for its clients. Still, the time and energy it took to create and re-create such specialized packages drained resources.

Principals decided that confusion had reigned long enough. An internal advisory council was organized to define the company's key values. For the external communication of those values, the firm brought in Rigsby Design. Lana Rigsby says her team—led by HNTB's visionary, international marketing director Laurin McCracken—had a clear directive: Create a unified identity, but don't make the system so strict that various divisions can't personalize or customize their collateral presentations. A single logo would not do, nor would

Elegantly simple nameplates printed with the firm's name serve as an extremely understated logo of sorts. Used on basic black and sharp yellow covers with simple elements like tabs, the effect conveys high style and smart engineering, two crucial attributes the client wanted to stress.

French-folded covers can be mass-pro-
duced ahead of time, then accordion-
folded inserts, specific to different lines
of business, can be inserted later.

When Lana Rigsby of Rigsby Design
found these unusual pencil boxes,
she knew they would be perfect pro-
motional devices for HNTB: They
mimic the HNTB nameplate shape,
are elegantly designed and engi-
neered, hold a little gift, and enclose
a little surprise for the recipient.

Photography by Terry Vine

a hefty, inflexible graphics standard manual.

Party to initial discussions within the internal
team, Rigsby could discern immediately that the
company's greatest strength was how the design
and planning people worked very closely with the
engineering people.

"Their architectural design is so elegantly engi-
neered that it works beautifully. We really latched
on to that," Rigsby says. Important, too, was the
ability to customize materials for particular clients.
"What they send out for a resort design shouldn't
look the same as what is sent for an airport pro-
ject," she adds.

Standard pocket folders, stuffed with informa-
tion sheets, booklets, and brochures, were the
main promotional vehicles used by HNTB, as well
as by its competition. Many high-end competitors
used boxes to deliver their materials.

"You get an easy-to-assemble presentation, but
the recipient has to do all the work: He has to put
everything back in and organize it—and pieces can
walk off," says Rigsby.

A more elegantly engineered solution would be
more emblematic. Rigsby actually closed her office
for four days to allow her staff to consider the func-
tional design of various print components. They
also completed a forty-page profile on the color
yellow, one shade of the neoprene material that
quickly emerged as a favorite cover material.
Neoprene, the same rubber used to make scuba
gear, also offered a durable, protective cover for
proposals that must survive for many months.

A number of diverse and innovative carriers
were comped, but the winner was a neoprene-clad
workbook with an expandable Tyvek spine, all
held shut with an elastic band. The book can hold
just one brochure or up to a four-inch-thick stack
of Wire-O material. Tabs allow pages and sections
to be rearranged in any order. Square stamps offer
even more customization: Applied to covers alone
or in multiples, they indicate what is inside and
target the type of design described.

Subtle but strong on the covers is one of three
new HNTB marks, not logos as much as umbrella
titles. But the bold color, combined with the book-
plate and distinctive stamps, present an unmistak-
able identity.

This is a redesign in progress: It not only
meant reaching consensus on the physical

These comps show other ways the
nameplate device might be used
as a transparent element on an
illustrated cover.

Applied to business correspondence
papers, the nameplate device works
just as beautifully. Instantly familiar
even in its subtlety, the device allows
the work or the message of the firm
to come through.

attributes of the new system, but also helping
HNTB staff embrace it philosophically. Toward
that end, as new components are implemented,
Rigsby and her staff will meet with HNTB
employees to explain the how the system works
and the logic behind it, and even to share competi-
tor's materials.

"It's amazing how collaboration and follow-up
can make a difference in a system's success,"
Rigsby says.

CREATIVE DIRECTOR:
Lana Rigsby

DESIGNERS:
Lana Rigsby, Thomas Hull

PHOTOGRAPHER:
Hedrich-Blessing

COPYWRITER:
Lana Rigsby

PRINTER:
H. MacDonald Printing

PROMOTING GROWTH

—JOHN POWNER, PRINCIPAL OF ATELIER WORKS, ON
PROMOTING GROWTH THROUGH SOUND GRAPHIC
DESIGN ADVICE TEMPERED WITH EMPATHY—

"With any new or amended identity, there has to
be the will to change, the acknowledgment that
things could be better. The bigger the company, the
more difficult this becomes because the lines of
communication and the implications of change are
more complex.

"The problem with designers is that we tend to
be idealists. We constantly see opportunities for
improvement, but they may well obscure the reali-
ties that the client faces. So you have to hold back a
little and allow yourself to understand those issues
and help the client to see the opportunities.

"You must start as you mean to go on. I take
great pains to explain the thinking behind a given
solution—less of, 'Here you go; isn't this great!' but
more like 'Here's where you could be—isn't THAT
great!'

"As a designer, I have high expectations of my
clients and myself. I always remember, however, that
for many, the creative process is a great leap of faith—
unfamiliar territory that requires a particular kind of
responsibility and trust. I find myself constantly
assessing a project. What are the other agendas? Am
I dealing with someone at the right decision-making
level? Are they really understanding the benefits the
work could bring?"

Before

Polaroid is the world's fifth most valuable brand,
so its highly recognizable logotype and mark are
extremely powerful visuals. The company's Digital
Imaging division needed an identity that related to,
but was distinctly different from, this identity.

After

By turning the pixel mark from squares into diamonds and adding a subtitle and a lens, the relationship between the parent company and its division is evident, but the new logotype and mark have a fresh, distinct look.

Atelier Works for Polaroid Digital Imaging

Challenge: Create a separate but related identity for a division of a company with one of the world's most recognizable corporate identities.

ONE OF THE MOST DISHEARTENING THINGS A designer can hear from a client is to "rework this, but don't change a thing." Designers at Atelier Works were faced with this situation when they created an identity for Polaroid Digital Imaging. The parent company, Polaroid, is the world's fifth most valuable brand, so that portion of the new division's name would have to remain utterly unchanged. But it should be massaged into a new identity just the same.

The Digital Imaging group markets high-tech presentation products, such as digital cameras, scanners, printers, and projectors, aimed at business professionals and sold through a network of distributors, dealers, and trade publications. "The managers in Digital Imaging felt they needed a stronger personality," explains Atelier principal John Powner. "This was a major new business opportunity for them, and they needed to

identify themselves strongly in the market."

But relating to a parent brand, particularly one as powerful as Polaroid, can be dangerous. "Consumers might just think this is some new kind of film," says Powner. His designers had to find a new way to bridge the gap between the company and the consumer.

Atelier explored several directions, such as filling the *P* in the original Polaroid with pixels and trying different lens-related solutions. But the ultimate solution actually related very closely to the original Polaroid logotype: The new spin was turning the Polaroid color pixel from a square into a diamond and drawing the digital imaging part of the name to match the logotype.

"It relates to the parent brand, but it is just different enough," Powner says. His presentation to Polaroid—which follows—details the logic and process behind Atelier's solution.

DESIGN FIRM:
Atelier Works

DESIGN DIRECTORS:
John Powner, Quentin Newark

DESIGNERS:
Annabel Clements, Ben Acornley, Jon Hill

PHOTOGRAPHER:
Peter Wood

COPYWRITER:
Pauline Chandler

photographic
imaging

high resolution
imaging

electronic imaging
systems

The Polaroid logotype is the powerful and widely recognized brand of the corporation. It is normally shown in a special Polaroid blue color.

The original Polaroid pixel is an eye-catching and memorable way of introducing color—a modern rendition of the color spectrum.

Overall, Polaroid's business activities fall into three areas. [This project is] concerned with the Electronic Imaging Division.

Electronic
Imaging
Systems

electronic imaging
~~systems~~

electronic imaging

electronic**imaging**

The [then] current Electronic Imaging Systems logo used in the U.S.

[Atelier's] first recommendation was that the word *systems* be dropped. Visually, the result is easier to read; the word *systems* implies a less flexible range of products.

To make the description more distinctive, the space between the words has been removed. *Imaging* is emphasized in bold. To identify it with the Polaroid logo, the dots on the *i*'s have been deleted.

digital cameras

film recorders

scanners

projectors and
panels

When combined with the Polaroid logo, the divisional description sits comfortably close.

There are four main product lines within the Electronic Imaging Division.

The common element in all these products is a lens or electronic eye.

The lens is always contained within an outer casing or box.

Electronic Imaging products also interpret high-quality digital color.

[Atelier] combined these three core features: lens, box, and color pixel. The lens has been tilted to add clarity.

The resulting lens plus pixel box in color.

To simplify the device, [Atelier] identified the lens and pixel to be the most important core features. The lens was made slightly convex to add emphasis.

The same device must also work well in single-color applications.

The combined logotype and lens pixel representing the Electronic Imaging division.

The mark must be successful when used at different sizes.

Ultimately, the aim would be to recognize Electronic Imaging purely by its distinctive pixel lens.

Atelier created a graphic device that linked the diverse products in a simple three-step process. Each three-step process centers on a Digital Imaging product and has an origin and a final result. The device is an integral part of the Digital Imaging division's marketing.

A CD containing the logo and three-step process drawings at high-resolution, plus all product photography prepared for print reproduction, were distributed to local marketers (pages from its accompanying booklet are shown here). The disk (opposite) enables them to produce advertising, direct mail, and trade show materials quickly and inexpensively, while guaranteeing the identity's overall consistency.

Polaroid
Corporate Identity Program

**Defining
Digital Imaging**

Macintosh CD Rom

BMR Design for Vestre

Challenge: A small furniture company's identity has less design flair than the products it produces.

DESIGN FIRM:
Bergsnov, Mellbye & Rosenbaum

ART DIRECTOR:
Sarah Rosenbaum

DESIGNER:
Sarah Rosenbaum

INTERNET DESIGN:
Anna Benckert

PROGRAMMING:
Max Jones

VESTRE IS A FAMILY-OWNED AND RUN company in Norway. It markets furniture in Norway, Sweden, and France. In the last few years, the company has focused on the design aspect of its products, engaging top industrial designers to develop a prize-winning furniture series.

But as its product line matured, its identity languished. When Vestre began working with Bergsnov, Mellbye & Rosenbaum (BMR), it had an uncoordinated mix of printed materials produced by different design studios plus an identity that was not as well designed as its products.

The original identity centered on an inverted triangle with the company name centered in its top. "This is a difficult shape to work with and not very attractive," says BMR principal Sarah Rosenbaum. "We thought the triangle could become the *V* in Vestre. This idea came into my head in the very first meeting." At the second meeting, the client decided to change the company name from Vestre Reime to Vestre, and the designers applauded his choice. The shorter name presented many more design options.

After trying many different black-and-white applications of the triangle in the identity design, the final mark emerged: A very professional and stylish basic black box with the company name seated comfortably at its base.

The old identity used Futura, Avant Garde, and another unidentifiable, digitally distorted face. This forced assembly of sans serifs, meant to communicate the geometric qualities of the furniture product, felt awkward. So BMR shopped for a single geometric face, finally deciding on Avenir. (For Internet use, the designers will use Verdana.)

The colors chosen for the identity mimic some of the materials used in Vestre's furniture: silver and a warm orange or wood color. Grid lines are printed on letterhead and notepads, evoking a sense of exacting design.

The client liked the first sketches of the new identity so much that he immediately asked BMR to redesign all of his printed materials, including a three-ring binder, his business papers, and his Internet site.

Rosenbaum says that the client's attitude toward all of this reworking has been admirable. "He had not budgeted for anywhere near the amount of work we have done in the last four months, but he has shown a completely professional attitude toward the use of design, being able to see the value in implementing the new identity in

The new Vestre mark takes the
triangle from the original design and
transforms it into a *V*. The simple
black box makes an elegant
container for the simply printed
logotype.

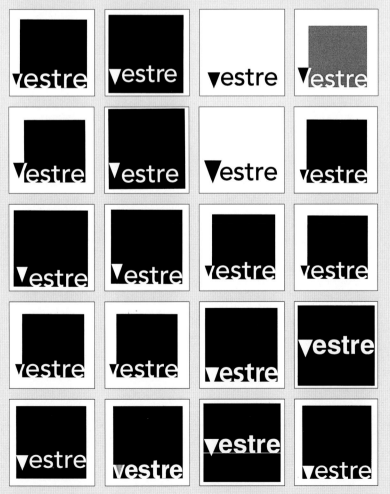

The idea for converting the inverted
triangle back into a *V*—its likely ori-
gin—presented itself early. But BMR
continued to create trials, experi-
menting with weight, spacing, sizing,
and color.

Vestre's original stationery system was drab and uninspiring (left). The new system uses silver—an industrial color—and a warm, orange brown—an earthy color—to reference the product's building materials. The look shows a much more polished and design-savvy attitude.

The new three-ring binder (far right) was designed to retain the same basic look as the old one, using brown chipboard. BMR found a better grade of board and, instead of printing on it, added stainless steel labels. A similar but smaller stainless label on the spine that carries address and other contact information is produced in mass quantities and is also applied to furniture for permanent contact information.

Even product sheets have a more polished attitude: The grid system used throughout the new identity system (near right) lends a natural organization to otherwise static pages.

all the major parts of his of communication materials."

The job has remained efficient, though, because the owner basically is the company, and he is completely accessible to the designers. "Most often," Rosenbaum notes, "the decision maker is not intimately involved in the design development but is present only in the beginning and at the end of a job. This means a more cumbersome, ineffective working process, working—and

guessing—together with non-decision makers."

Vestre also has made another streamlining decision: to have BMR do all of its identity design in the future. This eliminates the need for a manual or lists of rigid rules. "We make up variations on the style as we go along," Rosenbaum says, "while keeping an eye on the continuity. This is a very inspiring way to work with an identity."

Sleek four-color product brochures were a new addition to the Vestre identity, which previously reserved color for simple product photos. Again, the grid creates structure.

Before

The centerpiece of the original Nando's identity (left) was a cockerel, drawn in a rather unemotional, geometric style.

After

The redesigned cockerel (right) reveals many of the subtle refinements of the new Nando's identity. The red is bolder (as are other colors not shown here); the drawing style is looser; and the bird has a more ethnic, folksy feel.

DESIGN FIRM:
Cross Colours

ART DIRECTORS:
Joanina Swart, Janine Rech, Adele Wapnick

DESIGNERS:
Joanina Swart, Janine Rech, Adele Wapnick

Cross Colours for Nando's

Challenge: Create a lively but comforting identity for a restaurant chain opening stores around the globe, one that ensures a consistent experience for the world traveler wherever he or she might roam.

NANDO'S RESTAURANTS' SIGNATURE MENU item is a Portuguese specialty, Peri-Peri chicken—butterfly-cut, marinated in a secret blend, grilled on open-flame grills, and repeatedly basted with special Nando's sauces while customers watch. (Peri-Peri is the Swahili name for *chili*.) But more than just the company's products are unique: It also promotes a culture and a traditional way of life, where people can savor the experience of the restaurant as well as the food.

"Their customers are drawn to the magic and warm hospitality that is the Nando's way," explains Adele Wapnick of Cross Colours, the design firm that helps Nando's maintain its advertising and marketing appeal. "In everything they do, there's a sense of an older, less complicated and more personal world, where the spirit of the Portuguese thrives."

The company began in South Africa, but it is making inroads around the world: Today, it also has stores in the United

Kingdom, Australia, Canada, Malaysia, Israel, Saudi Arabia, Egypt, Kenya, Zambia, Malawi, Namibia, Botswana, and Mauritius. It anticipates entering the United States soon. The typical Nando's customer is worldly and well-traveled: In fact, wherever they go, these people tend to gravitate toward the comfort zone Nando's offers.

If consumers worldwide were to develop an affinity for the brand as the company continues to grow, Nando's needed more consistency among its locations. Nando's executives in various countries had used their discretion with the identity, resulting in a wide mix of different styles, tones, colors, and so on. The identity also was a bit static and old-fashioned, no longer matching the fun, irreverent attitude the brand had developed over time.

Because the brand had tremendous equity in South Africa, where there are 137 stores, Cross Colours worked to move the identity forward by changing the logo only

The first thing addressed was the name, which was changed from a rigid typestyle to a fluid, handwritten look. The marquee's soft pink-red color was also changed to a stronger, dirtier red. In fact, the entire color scheme was made deeper and richer, as shown by the back sides of several redesigned stationery sheets .

The new Nando's menu clearly
shows how loose and fun the new
identity can be. The look is of a com-
pany completely comfortable with its
personality.

slightly. The rest of the graphic identity has changed significantly in its portrayal of brand values. The designers also knew that a clear but flexible standards system was a must: So many different people would be using it, looking to it for guidance, but also desiring some amount of creative freedom.

Cross Colours created a system that capitalized overall on the richness of the textures, colors, and heritage of the Nando's brand. Specific modifications were small but significant.

- A stronger color palette of brick red, dark green, and solid gold, often printed on hefty, flecked, brown paper, created a more forceful look in all of the graphics.
- A hand-drawn face with a more fluid nature for some text and headlines spoke to the fun of Nando's spirit.
- The leaves, which illustrate the gentle

Portuguese culture, were made more in proportion with the logo.

- A background scroll element was made shorter, neater, and more efficient.
- The cockerel was redrawn in a looser style. He is more solid and cohesive, "yet he hangs loose!" says Wapnick. Still, he remains largely unchanged, in keeping with Cross Colours' original plan.

The new identity is currently being rolled out, and stores in every country have welcomed the changes and the standards kit that provides a means for them to control the identity at their location. Customers have reacted positively as well. But Adele Wapnick doubts that many will notice the specific changes to the logotype and cockerel mark, "[w]hich I believe is the responsible route in redefining a logo or symbol identity," she says.

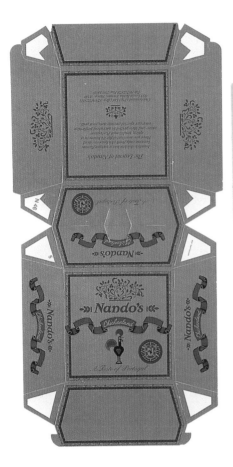

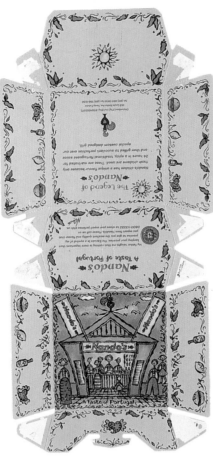

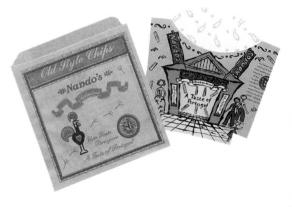

Food packaging carries through with the brighter color scheme and more confident, welcoming design.

Nando's also sells its special sauces. Its old labeling system (left) was so similar across the board in color and type that it was difficult to tell one variety from another. The brightened, enlivened redesign (right) distinguishes each type easily.

Even the new Nando's Identi-Kit, distributed to stores around the world, has the texture and color of the new identity. Several inside pages also appear here.

Phase two of the Nando's identity makeover will include new store-fronts, interiors, menu boards, and signage. Several comps of proposed designs appear here.

Nando's advertising also received a facelift. The general approach is the same, but the presentation has much more life and texture.

Before

After

Dogstar for Heavy Talent

Challenge: A sole proprietor wants to recast her company's identity so that it sells her work, not her name.

LIKE MANY SMALL-BUSINESS OWNERS, Morgan Shorey used her own name for her artists' and photographers' rep business: Morgan Shorey, Inc. But as her business as an artists' and photographers' representative grew, she wanted a new name, one that focused on what she did, not on who she was.

"We're not a style-based creative office. We don't have a food guy and an architecture guy and all that. You call here if you really want the heavy talent," says Shorey, who contacted Rodney Davidson at Dogstar for help to find her new identity.

The phrase "heavy talent" was an ideal name for her firm. Shorey and Davidson agreed. Aside from its literal meaning and being on the whimsical side, she and the photographers she worked with at the time all have achieved large stature. Shorey liked the idea, and Davidson knew the double entendre would lend itself to plenty of conceptual, illustrative solutions.

The artist began by quickly sketching page after page of tiny thumbnails. His first trials portrayed superheroes and other larger-than-life characters. The tiny figures lifted or pulled or in other demonstrative ways struggled with heavy portfolios. Some solutions were all illustration, while others pulled in type as well.

One direction emerged as a favorite: the lifting figures. It graphically represented the name, was memorable, and had the humor the client wanted. But Davidson felt he had not found the right solution yet, and he went back to the drawing table.

This time he came up with the idea of a crane lifting a large portfolio. The skew in scale emphasized heavy even more than in his earlier designs. Yellow and black were appropriate colors for heavy equipment, but Davidson also liked their bright, energetic qualities. The idea for the type portion of the identity was resurrected from some of his first sketches.

DESIGN FIRM:
Dogstar

DESIGNER:
Rodney Davidson

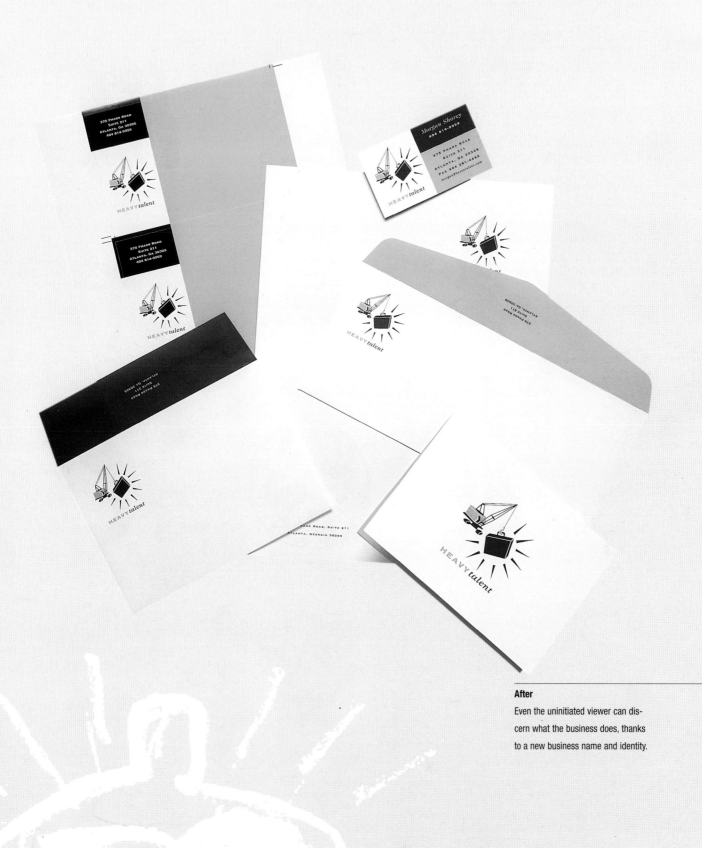

After

Even the uninitiated viewer can discern what the business does, thanks to a new business name and identity.

Rodney Davidson of Dogstar began
his exploration of the Heavy Talent
identity by sketching dozens of
thumbnails of superhero-like charac-
ters. The circular, self-contained
marks appealed to him because they
were very illustrative. But the concept
"heavy talent" seemed clearer in the
versions where the figure was lifting
a heavy portfolio.

Typographic solutions were also explored, but these didn't have the same whimsical appeal of Davidson's earlier sketches.

Davidson and Shorey were trying to decide between these two figures when the designer decided that a better solution had yet to be found.

"It was exactly what I was looking for. The focus is totally on the large portfolio as it dwarfs the crane, swinging toward the viewer," Davidson says. "I believe this concept is superior to all the rest because it is unexpected, unique, has a concept played out in a visual pun, and is not gender-based."

Implemented in early 1998, the new mark has noticeably affected Shorey's business. In particular, it distinguishes her office from other artists' reps in the area. "When people see it on a box or package, they know that this is something very different."

Back at his drawing table, Davidson happened upon the concept of a crane lifting the portfolio that made the concept of "heavy" much more memorable.

Wang Xu for China Youth Press

Challenge: As a publishing company begins to expand its operations outside of mainland China, it needs a more recognizable presence in non-Chinese-speaking countries.

In mainland China, many enterprises—especially publishing houses—like to use calligraphy of well-known people for their logotypes. One such company, China Youth Press, was founded in 1949 and is the same age as new China. It is one of the largest publishing houses on the mainland, publishing literature, art, and intellectual books. Since its inception, its identity has been formed around the calligraphy of Lu Xun, the Chinese literary giant of the 1930s.

But in the last twenty years, with the more open economic policy that has been developed in China, communication between the press and the outside world has increased. Comparing its identity with stronger identities of foreign publishing houses, the company realized the necessity of forging a new, more competitive presence.

China Youth Press has been trying to recreate its identity for almost ten years. But since all efforts were handled piecemeal, the results lacked continuity and caused confusion. In late 1998, China Youth Press asked graphic designer Wang Xu to redesign its corporate identity program.

Wang Xu began by exploring imagery that would resonate with Chinese youth. Perhaps the most significant event is the May 4 movement of 1919, an anti-imperialist, anti-feudal, political, and cultural movement influenced by the October Revolution and led by intellectuals. The youth at that time usually were pictured wearing scarves, generally atop blue clothing. This imagery gave the designer a starting point: Initial explorations included realistic and abstract versions of a young man with a scarf around his neck and a book in his hand.

From there, Wang Xu made the concept even more abstract. A simple twig and a leaf were positioned so that they either resembled a human figure with an uplifted arm or an extended human hand. Both designs formed the letter *Y* for *youth* and expressed vigor and vitality. Another exploration turned a young man's head and scarf into a book, but the designer was not happy with this direction.

Finally, the designer began considering the letter *C*, for *China*. The circular form of the character, combined with an abstracted, extended hand, formed an interesting sun image. But turning the hand downward created an even more engaging mark: The fingers now looked like pages of a book or a stack of books.

The designer knew he was on the right track when he discovered that the English pronunciation of *youth* is similar to the Chinese pronunciation of *young lion*, which the new mark also resembled. It was a happy coincidence: The lion's image stood for a rousing, strong competitiveness that China Youth Press wanted. The client accepted the mark at once.

"Compared with other publishing houses in mainland China, China Youth Press now has a stronger consciousness about having an international visual identity. As the new corporate identity needed to be international, it was better to use a lion image than a people image," says Wang Xu, adding that he felt that the trust and confidence his client gave him truly helped make the project a success. "China Youth Press is one of our best clients," he says.

DESIGN FIRM:
Wang Xu & Associates Ltd.

ART DIRECTOR:
Wang Xu

DESIGNER:
Wang Xu

After

The publishing company's new identity centers on this lion-like mark. It has the feeling of its home country, but the addition of English type turns it into a worldwide symbol.

Graphic designer Wang Xu began his redesign by considering concepts that said *youth* and *China*. He explored imagery attached to the May 4 movement of 1919, an anti-imperialist, anti-feudal, political, and cultural movement influenced by the October Revolution, during which young people were usually seen wearing scarves. He developed literal and abstracted ideas.

Also in an effort to express youth, these studies used abstracted twigs and leaves that eventually turned into a reaching hand.

Here, the image of a young man's head with the suggestion of a scarf turns into the shape of a book. However, Wang Xu wasn't happy with this approach.

To work in the concept of *China* more concretely, Wang Xu began exploring the letter *C*. Reintroducing the extended hand created an intriguing sunburst image, but turning the fingers/rays downward had an even more remarkable effect: The letterform was transformed into a lion, the perfect image to express vitality and competitiveness.

The 50th Anniversary of China Youth Press

To celebrate the fiftieth anniversary of China Youth Press in 1999, Wang Xu created this commemorative logo. On the threshold of a new millennium, the company's new mark gives it a more significant worldwide image.

STARTING OVER

—RON MIRIELLO ON STARTING AGAIN, AND
AGAIN—

"Earlier in my career, I felt that when
clients wanted to change one of my designs,
they were interfering, weakening the work.
But there were as many, if not more, times
when they made the work better, too. So
when their legal department says 'no, we
can't use this' and I've got two weeks to come
up with something entirely new, I try to
remember those times. Clients are not dumb.
They're partners.

"A good branding identity must cross
over all of a company's divisions—public
relations, advertising, legal, whatever. That's
why it's so electrified—an identity has to rep-
resent a lot of values. But a company can be
kind of schizophrenic about what it wants to
communicate because of this.

We have to become a journalist for the
client. We report on what they represent, ask
tough questions and then create a dialogue
that can become memorialized in the identi-
ty's content. The content might be latent, not
really obvious to anyone. But the brand
comes to symbolize those qualities.

"Think of creating a new identity as if
you are planning an experience for someone,
just as a director might plan out a movie.
What do you want them to experience? After
you agree on that, you can start the writing
and the casting."

Before

While the posters designed
by Massimo Dolcini in the
1980s are undeniably eye-
catching and well-com-
posed, the designer's style
was so recognizable at the
time that the identity
referred more to him than it
did his client, the
Municipality of Pesaro, Italy.

After
This poster forcefully depicts the Pesaro cultural department's new identity. Letterforms are used as objects and as art, and bold rules always frame event information. The spare, bold posters and invitations can be recognized easily. This image represents the title of a novel telling the story of a worker in a dump (*La discarica*). Both the can and the letters are depicted as rubbish.

Dolcini Associati for Municipality of Pesaro

Challenge: A city develops an accidental identity, then strives to refine it into something more useful.

THE MUNICIPALITY OF PESARO, ITALY, did not originally set out to develop an identity. But after Massimo Dolcini, founder of Dolcini Associati, created all of the posters and collateral materials need by the municipality's various governmental divisions throughout the 1980s, it slowly grew a very distinct identity. Unfortunately, because Dolcini's work was so recognizable, the public perception was that the design work was communications from the design studio, not the municipality.

For the next seven years, Pesaro's graphics became less coordinated, so the old identity began to fade. But in 1998, the Pesaro cultural office decided to resurrect the idea of a real identity and hired Leonardo Sonnoli, now art director of Dolcini Associati, to recreate its image.

"Mainly they wanted all of their communications to be easily recognizable, a sort of signature for all printed matter," Sonnoli says. "I wanted to create a new language for them, a sort of visual alphabet [that said], 'This is the voice or language of the public institution producing cultural events for the town.'"

Sonnoli interpreted his alphabet analogy literally: Influenced by the type-photo theories of Lazzlo Moholy-Nagy as well as the "letters as things" theories of Eric Gill, Jan Tschichold, and others, he developed a number of sketches that transformed letters into art. In some cases, the letterforms displaced or replaced other objects; in other instances, the letters themselves were the image.

Because he was producing posters and invitations, Sonnoli says that visibility was more important that readability. "People have to recognize immediately the subject, then [they can] read the information about the event," he explains.

Once he had his alphabetic approach nailed down, Sonnoli concentrated on the

Leonardo Sonnoli's sketches played with ways to treat letters as objects. He says that treating letters—usually used to convey written information—as art creates a visual/verbal hybrid, very different from other forms of visual communication.

layout for the pieces. To keep the printed matter recognizable no matter what art was used, he always used Foundry Sans for his type plus the same grid. A bold line is always place near the even information, which maintains the same tone on every piece.

The new identity has been a success: The events announcements have a very recognizable feel across the board. Citizens know immediately that a new occasion has been planned every time they see a new poster displayed.

The poster at right was made for a photographic exhibition on the Bosnian War. A bullet-pierced *B* is mixed with an exhibit photo.

Omnia mutantur, a Latin phrase meaning *all is changing,* was the title of an art exhibition of young artists. The egg is one of the most recurrent symbols in paintings during the Renaissance, the most influential art period in the Pesaro area.

Il lavoro delle donne (the women's work) was an exhibition on the folk needlework made by Pesaro-area women. The safety pin brings together the *d* of donne and a pink piece of cardboard carrying the opening date and hours. Usually, such a piece of cardboard is pinned on fabric to identify it.

This poster announced a lecture series on children's literature. The image is of a simple game—shadow puppets—combined with the first letters we learn: *a, b, c.*

This imagery represented a poetry lecture series. Sonnoli's inspiration was the visual poetry of the 1950s and 1960s. The subtitle, poetry *laboratory,* helped the designer find his solution. "It represents many boxes where the elements of the poem are: rhyme, different letters, words, punctuation, and so on.

Comune di Pesaro
Biblioteca Centrale

in collaborazione con la
Fondazione Cassa
di Risparmio di Pesaro

Venerdì 27 febbraio 1998 –
 Alberto Bertoni: Il pensiero metrico
Venerdì 6 marzo 1998 –
 Franco Buffoni: La traduzione poetica
Venerdì 20 marzo 1998 –
 Giovanni Nadiani: La lingua del dialetto
Venerdì 27 marzo 1998 –
 Rocco Ronchi: Il pensiero in poesia

Pesaro, Palazzo Montani Antaldi della Fondazione
Cassa di Risparmio di Pesaro, ore 17.30

Poeta per poeta
Poesia per poesia

Tra il dire e il fare
(Laboratorio poetico)

Dialoghi e letture critiche
a cura di Gianni D'Elia

PESARO BIBLIOTECHE

DESIGN FIRM:
Dolcini Associati

ART DIRECTOR, DESIGNER:
Leonardo Sonnoli

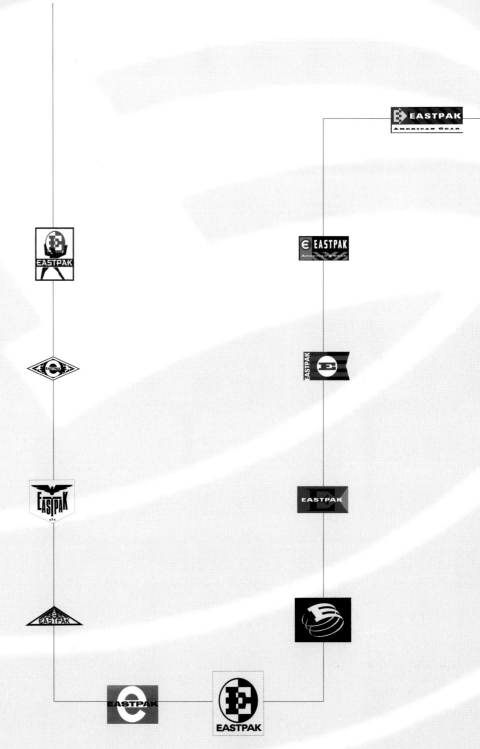

Miriello Grafico for Eastpak

Challenge: A brand with wonderful prestige and name recognition in Europe, but not as much acclaim in the U.S., needs an identity redesign that preserves the former and improves the latter.

AFTER COLEMAN PURCHASED THE EASTPAK BRAND name, it found itself with a quality line of backpacks with a split personality. Extremely popular in Europe, the Eastpak name in the United States was regarded as the poor relation of its main competition, Jansport. Eastpak was the brand your mom might buy for you because it was well-made and sensible. But most U.S. kids, teens, and young adults were more attracted to the competition's more colorful, graphic look.

Coleman asked Miriello Grafico to energize Eastpak's image and give it a bit more attitude. "The sky's the limit," Eastpak representatives told Principal Ron Miriello early on in the project, a guideline that his designers immediately embraced. The design team completed many studies of Eastpak's target audience, formal and informal—Miriello often would approach young people, ask them what they liked and disliked about their backpacks, and how they felt about the top

After

After a long and somewhat circuitous
route, the new Eastpak identity was
created. In addition to its more pow-
erful look, it also was designed to be
part of the product more, rather than
just a label.

DESIGN FIRM:
Miriello Grafico

ART DIRECTOR:
Ron Miriello

DESIGNERS:
Ron Miriello, Monica Riu,
Michelle Aranda, Troy Viss,
Randy Klamm

PRODUCTION, APPLICATION:
Monica Riu

brands and why. Then the design team began
to think about how to turn the backpacks
into walking billboards.

A globe was part of Eastpak's original
design: Miriello designers began by looking
for ways to incorporate it, but they explored
many other directions as well. The firm even
dipped into product design: "[U]unlike a
corporate identity where the identity repre-
sents a service, this was for an old-fashioned,
kick-the-tires product," explains Miriello.
Suggested redesigns included a skateboard
bag, a bag with bungee wrap cords on the
outside, and less boxy and more organically
shaped bags. Designers eventually presented
to Coleman approximately one hundred logo
options, and Miriello felt sure that many of
the marks had hit the mark. But the client's
European representatives began to assert
themselves: Their audience identified per-

fectly with the existing logo, and all of the
proposed designs strayed too far from that
identity.

Then Miriello realized that instead of a
complete makeover, the assignment had
turned into a facelift. "This project involved
a lot of soul-searching on the part of the
client," Miriello says; "trying to get a grip on
what Eastpak was all about, its strengths,
weaknesses, and goals. Normally, I don't
want a client to use the design process to
organize their thinking. But in this case, it
became clear that a refreshed design would
be better than a whole new look."

Phase two referenced the original design
much more directly, with an added jolt of life
and attitude. The name became more read-
able, the globe returned in some designs, and
the original burgundy red was brought back
and revised as an element that identified

Nearly one hundred logo options were presented to Coleman in phase 1 of the project, but none appealed to the European sales force.

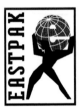
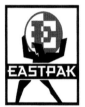
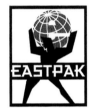

In phase 2 of the redesign, the product name became much more readable, and more attitude was injected through visuals and color.

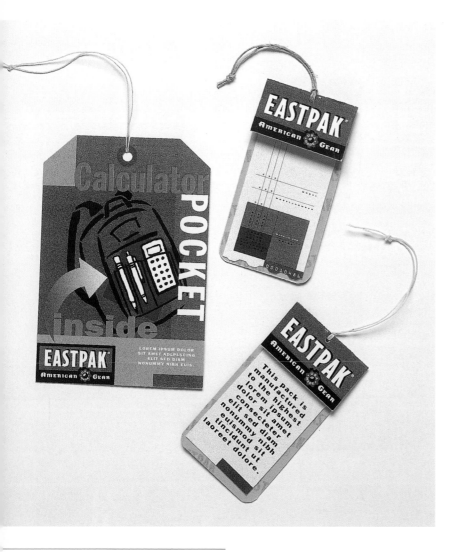

Hang tags with changeable color schemes were designed to point out the functionality and fun of the product.

Opposite: Also part of phase 2, these designs focused on the *E* element, turning it into a branding symbol.

solidly with the original.

Ultimately, designers decided to be more inventive in how they used the logo on the product. They suggested rubber extension labels and molded details that integrated the brand into the product, rather than just being stuck on it. Hang tags could change while the brand remained constant, and secondary color schemes could change. Miriello Grafico recommended that the client also change its image in other ways: Be a presence at youth-oriented trade shows—for instance, sponsor events like skateboarding competitions—and ratchet up the volume of retail advertising.

The redesign process took more than ten months, due to the many changes in direction. Still, Miriello was pleased with the results. "I'm glad we didn't settle too soon. If this is what they really want, then this was the best way," he says. "I'm glad we stayed with the project when the frustration with changing strategies mounted. In the end, it was about continuing to listen to what the business needed to succeed. That meant building on the strengths they didn't know they had."

After

The new identity began around the concept of drilled holes, but it quickly evolved into something much larger. The addition of a brilliant palette of papers allows color to play against color, speaking of the company's creativity and multilayer capabilities. The result is an identity with visceral and conceptual appeal.

Nestor Stermole for Nestor Stermole Visual Communications

Challenge: *When two creatives decide to combine their individual offices, settling on a single identity can be difficult.*

Rick Stermole and Okey Nestor each ran their own graphic design studios for a number of years. But when they decided to join forces, deciding on a single identity was tricky. It wasn't really necessary to retain any particular elements from their old studios—except perhaps for their own names—but they certainly didn't want to abandon their reputations as creative, in-demand professionals. Okey Nestor's original business was called Shankweiler Nestor, in which he partnered with Linda Shankweiler. Their logo was actually conceived and photographed by Rick Stermole: Its three-dimensional letters

announced the principals' names, but it said nothing about what they did. Stermole, on the other hand, relied on three bright colors and subtly dotted paper stock for his stationery system. The two identities were not similar in any way. "It's so difficult, trying to establish a business and bring in income," Nestor says of the process for thinking up the new design. "And now we're doing our own ID as well." He and Stermole brainstormed for vision words, terms that would describe what the new organization was all about. To test their favorite ideas, they faxed their lists out to key clients who were sympathetic to

DESIGN FIRM:
Nestor Stermole

ART DIRECTORS:
Okey Nestor, Rick Stermole

DESIGNER:
Robert Wirth

PRINTING:
Dickson's, SoHo Services, Continental Anchor

LASER DIE-CUTTING:
Laser Craft

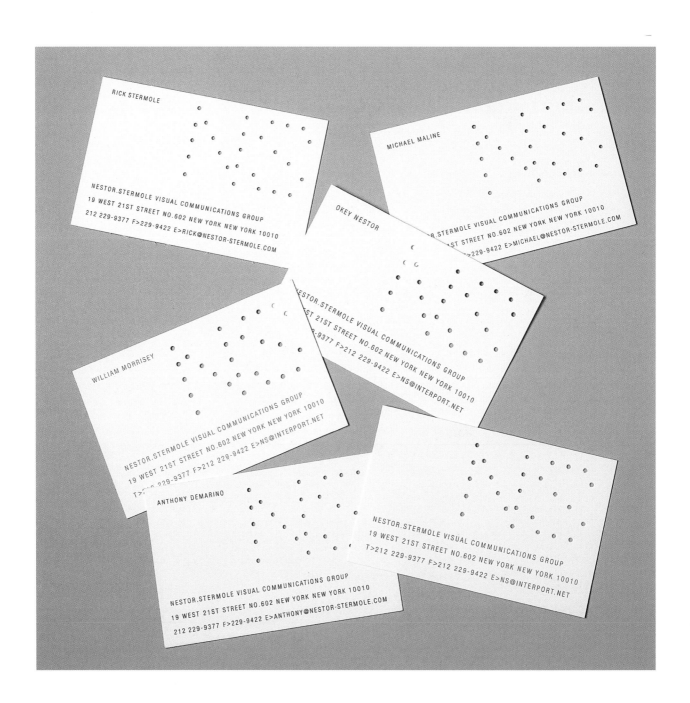

The first thing the new office needed was business cards. At this point, the hole pattern was punched with a die, but this caused production headaches. The designers later switched to laser cutting. The color on the laser-cut cards is very subtle but varied.

the new firm's plight. "It was horrible: Nobody liked any of the names." In the end, they decided on using their own names—Nestor Stermole Visual Communications. People knew who they were: Some new, esoteric, conceptual name had absolutely no equity. Still, says Nestor, such a defined name will make it difficult for them to add any additional partners in the future. The next step was to develop the graphical representation. "You grow as a designer and think about yourself differently from year to year.

We wanted to be very simple and tasteful, but to have an identity that would allow us to grow and make more of a statement if we want to," Nestor explains. The business name was so long that it would have been very difficult to work it into a single, memorable mark, so the designers shortened it to NS. Simply printing the letters on white or cream paper was clean and straightforward, but it seemed overly obvious. So the designers explored other ideas, among them die-cutting. In order for the design not to cut to

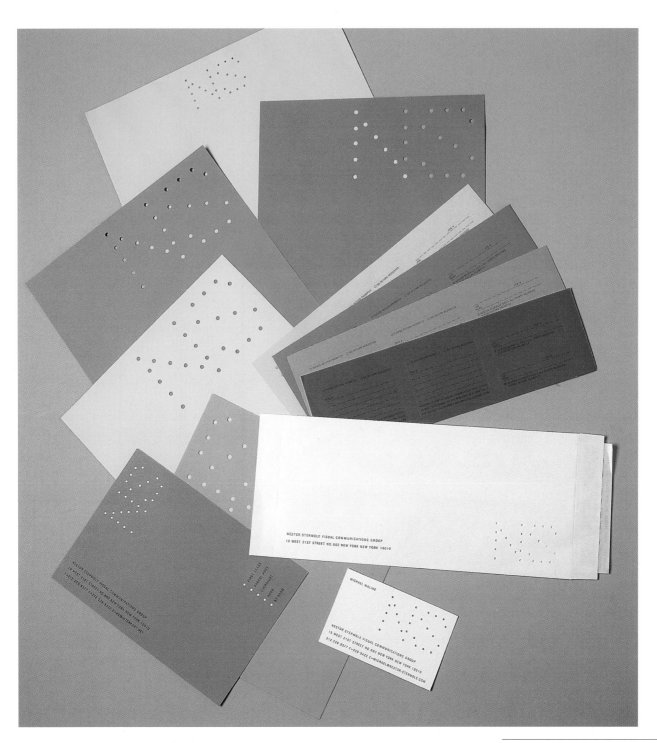

Nestor Stermole's brilliantly colored
stationery system is highly recogniz-
able and would no doubt stand out on
a recipient's desk, already overpopu-
lated with white and cream papers.
The drilled-hole pattern allows addi-
tional colors to show through from
behind. On components that must be
on white paper, such as memos and
fax sheets, the hole pattern is repre-
sented by a series of circles.

Nestor Stermole's presentation folder demonstrates the flexibility and growth potential of the punching motif and color system. Its plastic cover does not have to be printed because it carries the simple punch; inside, a hint of the color used on the stationery appears.

pieces the paper on which it die-cut, a series of punched holes was devised. But the printer's die was so small that it had to be cleaned out between every punch. "They gave us our business cards and told us not to come back," laughs Nestor. It was then that the die-cut holes concept really blossomed: Switching to laser-cutting, the designers decided to let the holes do more. Instead of just breaking the surface of the paper, now they would let more and more color show through. A paper palette of brilliant green, blue, red, yellow, red, orange, and yellow cre-

ated a new color story with each new piece of the stationery system. The laser-drilled holes allow additional colors to present themselves from behind. "You get a color surprise in every envelope. It's tough to know how to perceive yourself and to know how you want to be perceived," Nestor adds, noting that some design firms try to encompass their entire philosophy or style of work in their letterhead. "But it shouldn't jump out and accost you in a way that you don't want. Our identity is far more subtle than that."

Because any material can be drilled, the punches can be used in various ways, as shown by Nestor Stermole's exterior, wooden office sign.

Reverb for Avalon Hotel

Challenge: When a hotel ages in a less-than-graceful manner, it needs plenty of sound design advice to revive its sense of style and comfort.

DESIGN FIRM:
Reverb

CREATIVE DIRECTOR:
Susan Parr

SENIOR CREATIVE:
James W. Moore

SIGNAGE CONSULTANT:
Bob Loza, Cyrano, Los Angeles

SIGN FABRICATOR:
Mark Nelson, Carlson & Co., Los Angeles

THE NEW OWNER OF THE RECENTLY OPENED Avalon Hotel bought a legend *and* a building complex when he purchased an aging residential hotel south of Beverly Hills. In its heyday, the hotel—then named the Beverly Carlton—housed Hollywood Stars like Lucille and Desi Arnez and Marilyn Monroe looking for a quiet hideaway. When Brad Kornson took possession of the hotel, it looked more like a shabby apartment building. But he had a vision of bringing the legend back to life, and he brought in a team of talented interior designers, architects, and the design office of Reverb to help.

Reverb is known not only for its identity work, but also for creating complete images that go beyond the graphic design work. "We guide the message through advertising, promotion, public relations, magazine articles, and even investor groups," explains Susan Parr, one of three Reverb principals with Somi Kim and Lisa Nugent.

The hotel's new owner wanted to attract an "art director-style person," not tourists, but young working professionals who would appreciate a clean, modernist environment. Another attraction of the hotel was that it was a bit apart from the craziness of Beverly Hills. "Part of the image had to be about serenity and hospitality. We coined a phrase for it—enlivened serenity," says Parr.

She and senior creative James Moore met early and often with interior designers and architects involved with the Avalon project. They spent plenty of time on research the original hotel, unearthing a 1948 *Forum* magazine article about the design of the original building complex.

They were excited to learn that the structure's original interior design and identity were created by the celebrated designer Alvin Lustig. Beneath an old façade on the front of the building was a wall of tile, each square carrying a unique jack symbol designed by Lustig. It was from this visual that the new identity grew.

Before

Beneath a façade on the front of the old Beverly Carlton Hotel, installed in an earlier remodel, creatives at Reverb found these wonderful tiles, created by the famed designer Alvin Lustig when he designed the hotel's interior and identity in 1948. From this jack pattern the entire identity system for the revitalized hotel grew.

avalon hotel

9400 W Olympic Blvd Beverly Hills 800 535 4715

ah

After

A number of elements in the new
identity system can be seen on this
book of matches. From the old tile
pattern, Reverb designers split out a
jack symbol and a three-dot mono-
gram. Not shown here is another
flexible element, a flower. But the ini-
tials of the hotel—*ah*—make a
descriptive tagline for the hotel.

avalon hotel

Reverb likes to create flexible, multi-faceted identities that have depth, not single, stamp-like marks. This figure shows just a few of the ways the different components of the Avalon identity can be used.

The symbols translate nicely to embroidery as well as to printing. Even in these one-dimensional applications, they have a distinct three-dimensional quality.

Avalon

Avalon

Avalon

Avalon

AVALON

avalon

Avalon

Avalon

The designers played out the hotel name in a number of different typefaces, each with a very distinct personality.

avalon hotel

avalon hotel

a a a

A squared-off face borrowed from an old typebook had the right feel, and mixing styles of lowercase *a*'s added even more flair. But the designers modified the bowled *a* slightly, shortening its top stroke and elongating its square counter. This created a more balanced, calmer character.

"Any design we do has to have variety and a richness. We didn't want to take the 'glam' hotel approach of creating a single logo and sticking it on everything," Moore explains. "We picked up on the Lustig design and moved it and broke it apart."

From the original symbol, the designers split out the jack symbol, a flower and a three-dot monogram. Those pieces can be used alone or together on printed, stitched, and fabricated hotel paraphernalia. Another, less prominent, mark emerged from the initial letters of the Avalon Hotel—*ah*—by fortunate coincidence exactly the phrase the hotel proprietors want guests to utter.

To match the flavor of this uniquely mid-century design, the designers selected two faces: a script type for the hotel's name, a face that would have been found in hotels in the 1940s, and a squared-off face borrowed from a type book and modified. It was chosen for its friendly, welcoming feel; setting one *a* in uppercase and the other in lowercase adds to its informal charm and creates a nice sight line.

The interior of the hotel follows the modern, minimal feel of the identity: Earth tones, surrounded by tile, woods, and metals, create the sense of a calming oasis in busy Los Angeles. "This is a place for people to go and not be bombarded with celebrity attractions," says Parr. "It is a quiet place, but a lively place."

The hotel's lighted sign, still under fabrication, has a soft, welcoming shape. Like its typography, it has the flavor of an icon from the 1940s.

The interior design of the hotel, created by Kelly Wearstler Interior Design, projects a peaceful but stylish demeanor for this enclosed area.

The hotel's printed collateral has the same peaceful feeling. Shapes are soft, while the colors are modern and appealing.

By fortunate coincidence, the initials of the Avalon Hotel spell out the exact sentiment the establishment's owner wants guests to feel. This piece of the identity is reserved for more intimate items, such as robes.

Turn-Key Biotechnology

Facility Consulting for Young Companies

TkBio @ AOL.Com

Richard Bonomo

48 Mark Mead Road Cross River, NY 10518 (914)-763-9337	Research Manufacturing Operations

Before

Start-up Turn-Key Biotechnology's
original identity was really no identity at
all—just a typeset, card-shaped box.

Turn-Key Biotechnology

48 Mark Mead Road
Cross River, NY 10518

ph and fax: 914 763-9337
pager: 914 421-8955
EBI: 914 345-5537
e-mail: tkbio@aol.com

Richard Bonomo
President

After

Ellen Shapiro of Shapiro Design took
advantage of the new business'
memorable name to create an illus-
trated identity that is fresher and
more contemporary than any
competitor's mark.

Shapiro Design Associates for Turn-Key

Challenge: A start-up gets off the ground so quickly that it soon requires an identity that represents the high quality of its services.

LAST YEAR, TURN-KEY BIOTECHNOLOGY FOUND ITSELF IN the same corner many start-ups do. Its founder had felt sure that he could create some kind of identity for his creation; but business took off so quickly that the company ended up with what might be called an anti-identity: an all-type, ad-like business card that said nothing about the dynamic service it provided. "I wanted an ID that showed that this was a talented, creative company," founder Richard Bonomo says, "something that said that I'm going to be around for a while. It should be another detail in the high level of work that I do." Turn-key does exactly what its name says: It plans, designs, and outfits fully functioning laboratories for young and start-up biotechnology firms, including figuring out short- and long-term budgets and setting up entire computer systems. In lieu of an actual logo or identity, owner Richard Bonomo was depending on his card's tagline, "Facility Consulting for Young Companies," to explain his business. His promotional package was made up of word-processed single sheets and office-supply folders. Fortunately, Bonomo's expertise and reputation had brought in a number of significant projects, despite his lack of coordinated promotion. With an established track record, he knew it was time for a real identity, one that described his services in a more dramatic, memorable way. "Turn-Key wasn't one of those abstract names that needed an abstract symbol. Its name lent itself to visual solutions," Shapiro says, noting that this solution came to her almost immediately. "Richard was in a fresh, new business, so I selected colors that were associated with hip, new things. His competition uses a lot of blue, silver, and black; they look much more conservative." Shapiro believes that even the smallest firms, started in a basement or garage, must have an identity that reflects professionalism and competence. In fact, the process of developing an identity can contribute significantly to steering the budding company. "It can be aspirational. The process of coming up with image characteristics can help you decide what you want to be. Deciding what your business cards and stationery say about you is almost like doing a business plan," she says. Turn-Key's stationery system will be followed by a Web site and a large capabilities brochure.

We're at your service.

Your lab is waiting.

Turn-Key Biotechnology can make your dream lab a reality. Our expertise includes finding the perfect location, space planning, construction management, equipment lease/purchase, license applications, computer and phone system design and specification, even establishing operations systems. With us, your lab will be ready. Efficiently, quickly, inexpensively, beautifully. You'll be able to focus on growing your company, not finding space and furnishing it. **Click here** to find out more.

The Turn-Key logo can be taken apart for use on the company's Web site, still under construction. The clean green and orange colors communicate fresh ideas and energetic thinking.

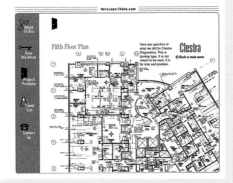

DESIGN FIRM:
Shapiro Design Associates

ART DIRECTOR:
Ellen Shapiro

DESIGNER:
Ellen Shapiro

Turn-Key
Biotechnology

storyboard for 16-page
self-cover brochure

1

Your lab
is
waiting.

2

No, not
that kind of
lab.

3

4

The lab you've
always dreamed of.
And that you need—
right now—to turn
your business plan
into reality.

5

6

We are Turn-Key Biotechnology and
We're at your service with everything
functional facility, inexpensively and
the perfect location, space planning,
lease/purchase, license applications
and specification, even establishing
focus on growing your company, not
us, your lab will be ready. Efficiently,

7

we can make your dream lab a reality.
you need to begin working in a fully
quickly. Our expertise includes finding
construction management, equipment
computer and phone system design
operations systems. You'll be able to
finding space and furnishing it. With
quickly, inexpensively, and beautifully.

8

How we do it:

1
2
3
4

9

5
6
7

10

11

We put our
expertise into
building the
infrastructure
that will help
your team devote
its energies to
scientific
innovation.

12

13

14

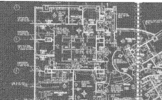

15

16

Turn-Key
Biotechnology

Call us.
1-800-LAB NOW.

The capabilities brochure's playful,
approachable design is a mirror for
Turn-Key's progressive offerings.
Even its shape feels more modern
than the mostly black, silver, and blue
materials offered by competitors.

A clean, white stock makes a perfect backdrop for Turn-Key's new stationery system. An image of cleanliness and precision is crucial to the firm's success.

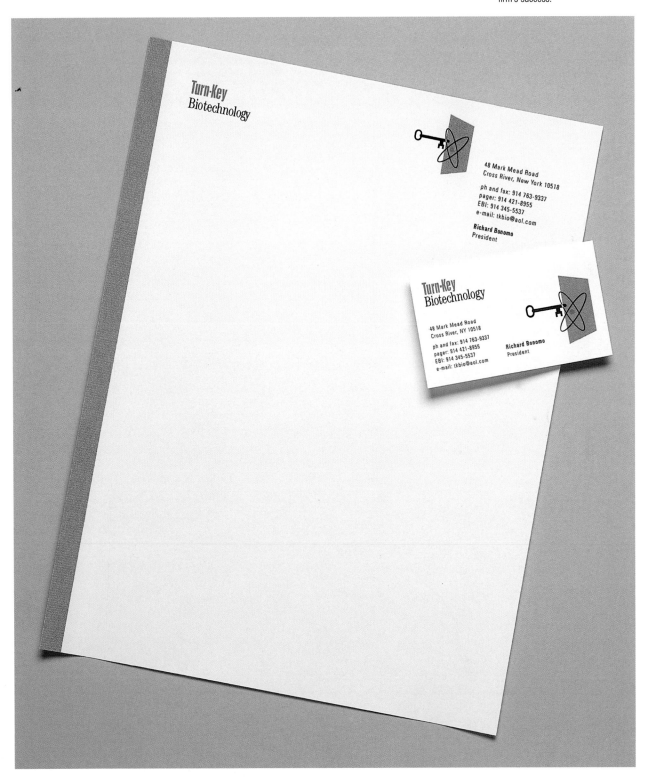

Directory

Atelier Works
The Old Piano Factory
5 Charlton Kings Road
London NW5 2SB
England
atelier@atelierworks.co.uk

BMR Design
Bergshov, Hellbye & Rosenbaum
Sagvn. 23C, inng. 2, 0459
Oslo, Norway
www.bmr.no

Concrete
633 South Plymouth Court (S T E. 208)
Chicago, IL 60605

Cross Colours
P.O. Box 412109
Craighall 2024
Johannesburg, Gautney
South Africa
cross@iafrica.com

Desgrippes Gobé & Associates
411 Lafayette Street
New York, NY 10003
www.dga.com

Design Park
DongSung Art Center
1-5, Dongsung-Dong
Chongro-Gu
Seoul, South Korea
kh@designpark.co.kr

Dogstar
626 54th Street South
Birmingham, AL 35212
pavarodney@aol.com

Dolcini Associati
Via Meniana, 3 47900
Rimini, Italy

Félix Beltrán & Asociados
Pisco 680
Colonia Lindavisla
Mexico City, Mexico 07300

Hopkins Baumann
236 West 26th Street, #5NW
New York, NY 10001
Hbhbnyc@ibm.net

Kan & Lau
28/F., 230 Wanchai Road
Hong Kong
www.kanandlau.com

Landor Associates
Klamatin House
1001 Front Street
San Francisco, CA 94111
www.landor.com

Miriello Grafico
414 West G Street
San Diego, CA 92101
pronto@miriellografico.com

MLR & Associates [Murrie Lienhart Rysner]
325 W. Huron Street
Chicago, IL 60610
www.mlrdesign.com

Nestor Stermole Visual Communications
19 West 21st Street, No. 602
New York, NY 10010

The Partners
Albion Courtyard
Greenhill Rents
London ECI M6BN
England
info@partnersdesign.co.uk

Pattee Design
138 Fifth Street
West Des Moines, IA 50265

Pentagram
1508 West 5th Street
Austin, TX 78703
www.pentagram.com

Pinkhaus/Designory
2424 South Dixie Highway
Suite 201
Miami, FL 33133
www.pinkhaus.com

Planet Design
605 Williamson Street
Madison, WI 53703
www.planetdesign.com

Reverb
5514 Wilshire Blvd., No. 900
Los Angeles, CA 90036
www.reverbstudio.com

Rigsby Design
2309 University Blvd.
Houston, TX 77005
www.rigsbydesign.com

Shapiro Design Associates
10 East 40th Street
New York, NY 10016

Turner Ducksworth
164 Townsend Street, #8
San Francisco, CA 94107
www.turnerduckworth.com

Wang Xu
3/F, No. 29 Tian Sheng Cun
Huan Shi Dong Road
Guangzhou, China
Gzxuwang@public1.guangzhou.gd.cn

Author

Catharine Fishel runs Catharine & Sons, a full-service editorial company that specializes in working with designers and related industries. Editor of *Dynamic Graphics* magazine, she frequently writes for *Step-By-Step Graphics, PRINT, DesignNet,* and other trade publications. She is author of *Paper Graphics* and *Minimal Graphics.*